LEGENDARY L

— OF —

CAMAS AND WASHOUGAL

WASHINGTON

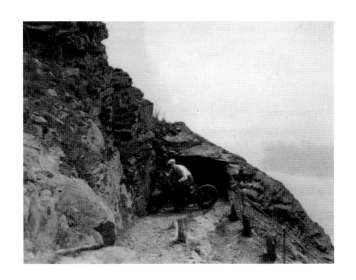

René Johnston
Carroll

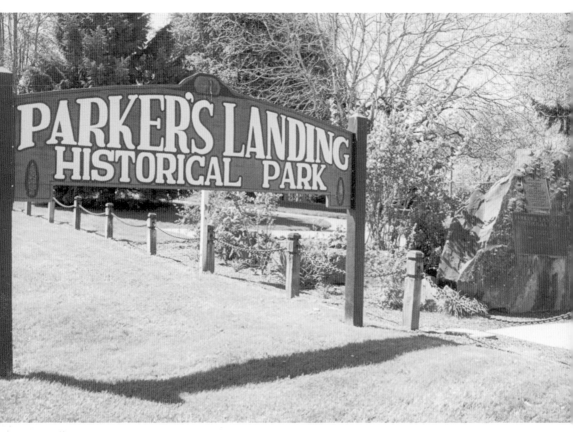

Parker's Landing Historical Park
Located adjacent to the Camas-Washougal Port Marina, Parker's Landing Historical Park commemorates David C. Parker, on whose Donation Land Claim this site is located. (See pages 11, 13, and 49.) (Courtesy of Two Rivers Heritage Museum.)

Page 1: Daredevil Seth Davidson
A true local legend, Seth Davidson was known for his large personality and daring feats. (See page 118.) (Courtesy of Multnomah County Archives.)

LEGENDARY LOCALS

— OF —

CAMAS AND WASHOUGAL

WASHINGTON

RENE' JOHNSTON CARROLL

LEGENDARY
LOCALS

Legendary Locals is an imprint of Arcadia Publishing
Charleston, South Carolina

Printed in the United States of America

Library of Congress Control Number: 2013936860

For all general information, please contact Arcadia Publishing:
Telephone 843-853-2070
Fax 843-853-0044
E-mail sales@arcadiapublishing.com
For customer service and orders:
Toll-Free 1-888-313-2665

Visit us on the Internet at www.arcadiapublishing.com

Dedication
To the Two Rivers Heritage Museum and the membership of the Camas-Washougal Historical Society, without whose loving preservation of local history this book could not have been created.

To my parents, Leroy Johnston and Carolyn Woodburn, whom I love and respect with all my heart. And to my children, Tom Carroll and Emily Carroll, who are my inspiration.

On the Front Cover: Clockwise from top left:
Princess White Wing (Betsy Ough) stepped over cultural lines for love of a British sailor (see page 10); Nan Henriksen, a visionary former mayor of Camas (Courtesy of Nan Henriksen, see page 31); Charles and Lizzie Cottrell created the first electric power in the area (see page 12); Dr. Mike Barratt soars as a NASA astronaut (Courtesy of Mike Barratt, see page 106); the Peter Erickson pioneer family of Washougal (Courtesy of Florence Wall, see page 23); Dr. Don Urie, a well-respected doctor in early Camas (see page 83); Dr. Louisa Wright, a beloved pioneering Washougal area doctor (see page 82); Carl Gehman, Camas business owner and hero (Courtesy of the Gehman family, see page 79).

On the Back Cover: From left to right:
Earl and Fae Miller, first Camas Days King and Queen (Courtesy of Maxine Ambrose, see page 44), Washougal Drum and Bugle Corps (Courtesy of Two Rivers Heritage Museum, see page 94).

CONTENTS

ACKNOWLEDGMENTS

The photographs used in this book, except where indicated with courtesy lines, were obtained with special permission from the Two Rivers Heritage Museum. My gratitude to the Camas-Washougal Historical Society Board of Directors, who allowed me complete access to the museum's wealth of records in its homestead collection, reference materials, photograph files, cemetery records, and the family files, which were filled with news clippings and other treasures of area history.

I would like to extend my personal thanks to several notable people who helped with this project. Local historian Curtis Hughey contributed the introduction for this book, shared his vast knowledge of the early pioneers, and provided facts to ensure accuracy. Thank you to Colleen Daniels for her assistance as the primary proofreader of the first-draft captions and for her enthusiasm and overall support of this effort. I appreciate Steve Daniels for his direction in research databases, which helped me find some of the missing pieces during my scavenger hunt for information. I am grateful to Mildred Piontek for her book *Washougal, Washington*, which provided needed background on a number of citizens, and for her help in double-checking my facts. Other proofreaders and local historians whose help I depended on were Alma Ladd, Lois Cobb, Virginia Warren, and Betty Ramsey.

And, of course, thank you to the families of those legendary individuals featured in this book. Many searched through attics, boxes, and albums for photographs and then, in some instances, trusted me with these heirloom images for scanning. Also, I appreciate their time in reviewing my captions for accuracy and for providing interesting family details that made the stories of their loved ones come to life.

INTRODUCTION

David C. Parker arrived at The Dalles, Oregon, in November 1844. He stayed until his son was born, and the family then floated down the Columbia River early in January 1845. They made landfall east of the mouth of the Washougal River, near earlier travelers. That summer, this group left to move northward, and Parker stayed. Prior to the Donation Land Claim Act of 1850, four other settlers claimed land near Parker; Richard Ough, Joseph Gibbons, Hamilton Maxon, and William Goodwin.

In 1854, Parker had eight blocks of his new property surveyed for the townsite of Parkersville, near the landing he built for river travel. This was the first American town on the north side of the Lower Columbia River, as Fort Vancouver was held by the British.

Just four years later, in 1858, Parker died. The town lots were auctioned off, with the proceeds going to the heirs. Several years later, eight more blocks were added to the town from farmland. Parkersville was the town between bluffs at Fishers to the west and Cape Horn to the east. In 1880, Joseph E.C. Durgan and Capt. Lewis Love, of the steamship *Calliope*, bought 20 acres from Richard Ough. They platted out the town of Washougal and built a new dock that had year-round deep water. The Parkersville landing could not be reached by steamships during low water.

Durgan built a store and post office in 1880 on a block of land he purchased in the new townsite of Washougal, at the corner of B Street and Pendleton Way. Fritz Braun also purchased a block of land on the intersection's northeast corner. Braun, seeing the Washougal area begin to prosper, moved his hotel from Parkersville to the southwest corner of his block and added a bar. The rest of the block was made into a visitor park, thus the name Park Hotel. By the end of 1881, Washougal was the main settlement, with two stores, a hotel, bar, butcher shop, two blacksmiths, a wharf, and several homes.

C.W. Cottrell built a flour mill in 1897 along the Washougal River at the river road. In August 1898, a bridge replaced the ferry that crossed there. In March 1899, a Portland industrialist built a creamery. It was purchased by Morris Webber in 1900 for $1,650. Steamboats transporting farm produce left Washougal at 7:00 a.m. for the Portland market and made the return trip at 2:00 p.m.

Washougal incorporated in 1908. The town had telephone service, Cottrell was supplying piped water, and, in 1909, a railroad was built through town. Cottrell sold his gristmill machinery in 1910 and began to use the water wheels to supply electric power to Camas and Washougal. In 1919, he put in diesel generators and created the new Western Power & Light Co.

Several Washougal businessmen sold $1,700 worth of stock to bring a wool mill to town in 1910. By 1912, the mill was failing and the Bishop family, owners of the successful Pendleton Woolen Mill company, bought it. By 1915, they were making quality products and turning a profit. The Washougal Woolen Mill merged with Pendleton Woolen Mill in 1953. Still operating in 2013, the mill manufactures many quality products, including the signature Pendleton Blankets.

Highway 14 to the east was completed in 1927 across the Cape Horn bluffs, opening up land to the north and east of Washougal. Henry L. Pittock became owner of the *Portland Oregonian* weekly newspaper in February 1861. He made it into a daily paper and, by early 1880, was in need of more newsprint paper than his mill on the Clackamas River could supply. He found suitable land a few miles west of the Washougal settlement. The deciding factor in this location was water from two lakes above a lower area next to the Columbia River. In 1883, the old Maxon Donation Land Claim of 641.6 acres was purchased by Pittock and a group of investors.

A six-by-ten-block townsite of LaCamas was laid out, with the mill adjoining the west side. A dam at the outlet of the lower lake was constructed, raising the water level 12 feet and thus eliminating the small waterfalls between the two lakes. A sawmill was built at the lower end of the pond created west

of the dam. A tunnel was dug from the log pond to the bluff above town, and this emptied into a new ditch across the face of the bluff to control water above the mill site. A small railway was built to move lumber from the sawmill to the bluff and into town. There were no engines on the railcars, only brakes were needed to take loads down the steep hill to the mill. Horses were used to return the railcar to the top.

By December 1884, the town consisted of three general stores, a drugstore, a meat market, and two hotels. The population was 153. In the first week of May 1885, the paper mill started to turn out white paper, but, on November 11, 1886, the mill burned down. The announcement came in April 1887 to rebuild the mill with more fire-resistant materials. By the next February, the mill was again producing white paper.

The mill employed 75 to 80 workers by October 1887 and turned out 6,000 pounds of brown paper and 12,000 pounds of white newspaper daily. The population was now 700 and the town had three stores, a drugstore, shoe shop, roll flouring mill, two hotels, a boardinghouse, dentist office, livery stable, meat market, jeweler, blacksmith shop, tonsorial artist, doctor, and real estate dealers. Steamer ships came and went twice a day in Camas. The ships came into the Columbia River slew between Lady Island and the mainland and were tied at the mill dock.

The Crown Paper Co. in Oregon City, Oregon, purchased the LaCamas Paper Co. principally owned by Pittock and his son-in-law F.W. Leadbetter in 1905. Then, in 1914, Willamette Paper Co. and Crown Paper Co. merged, becoming Crown Willamette. In 1928, Crown Zellerbach took over the paper mill, and in 1985, it was taken over by a British raider, Sir James Goldsmith, and broken up. The mill was sold to James River and, in 1997, merged with Fort Howard to become Fort James Paper Co. In 2000, Georgia Pacific bought James River. In 2005, Koch Industries purchased Georgia Pacific.

The paper mill grew through the years to include 16 paper machines. As no machine was labeled No. 13, the last machine was No. 17. At one time, the Camas paper mill made more variety of paper than any other mill in the country. The mill is down to two machines in 2013.

—Curtis E. Hughey
May 2013

CHAPTER ONE

Pioneers and Immigrants

Many of the first to settle in the area arrived after the dangerous journey along the Oregon Trail as part of a wagon train. It was a time when many of these immigrants would continue south to pursue riches in the California Gold Rush. For those who chose LaCamas and Parkersville as their home, their riches were in the fertile fields, ease of river transportation, and new business opportunities. Richard and Betsy Ough, David Parker, Joe Durgan, and Lewis VanVleet were among the first to arrive, becoming community and business leaders. Their pioneering spirit provided the vision and foundation for the towns of Camas and Washougal.

The people who followed took out land claims and applied for homesteads. They carved out their homes, farms, and businesses from the thick forests or along creeks that now bear their names, such as James Jones (Jones Creek) and Joe Gibbons (Gibbons Creek). These settlers included Albert Goot Sr., whose products from his Swiss Dairy in Washougal made their way to market in Portland, and Roy Dobbs, who worked as a banker and a farmer. P.B. Erickson was among the many Norwegian immigrants to farm atop Mount Norway in Washougal. This chapter highlights some of Camas's and Washougal's first residents, who created the communities and set a course for generations to come.

Richard and Betsy Ough

Among Washougal's earliest settlers, two formed a very unlikely couple. Richard Ough (1798–1884) and Betsy Ough, also known as Princess White Wing (c. 1818–1911), fell in love at first sight. He was an English seaman who worked on Hudson Bay merchant ships, and she was the daughter of Chief Schluyhus. After a chance meeting about 1838, Ough was so taken by the young princess that he made the daring move to return to the tribe on his own to see her again. Impressed by his bravery, the chief listened to Ough's offer of blankets, beads, knives, a looking glass, and a hatchet in exchange for his daughter. But the chief declined, fearing he would never see her again. After Ough made repeated visits to ask for White Wing's hand, the chief believed his sincerity and agreed to the marriage, only if Ough built a home for the couple. Construction began the next day, and the wedding date was set. A fleet of 100 canoes carried the chief, the bride, and Indian guests to the Fort Vancouver waterfront for the ceremony. Upon inspection of the new home, the wedding took place. Dr. John McLoughlin (1784–1857) conducted the service as civil magistrate of the British Crown, believing this marriage would help the relationship between Indians and the white men. Once married, Mrs. Ough would go by the name of Betsy. As trade began to slow down in the area, McLoughlin counseled the couple to seek out good land to begin farming. Betsy wanted to live by the Washougal River, so Ough built a log cabin there in 1849, and in 1853, he applied for a Donation Land Claim. The couple went on to have 10 children between 1839 and 1863. When the town of Washougal began to move from Parkersville in 1880, Joe Durgan (1827–1898) and Lewis Love (1818–1903) purchased 20 acres of Ough's claim to plot out the new city.

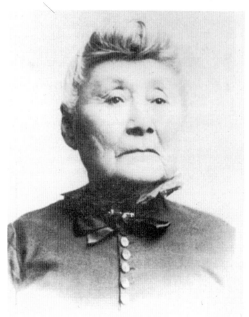

PARKER'S LANDING

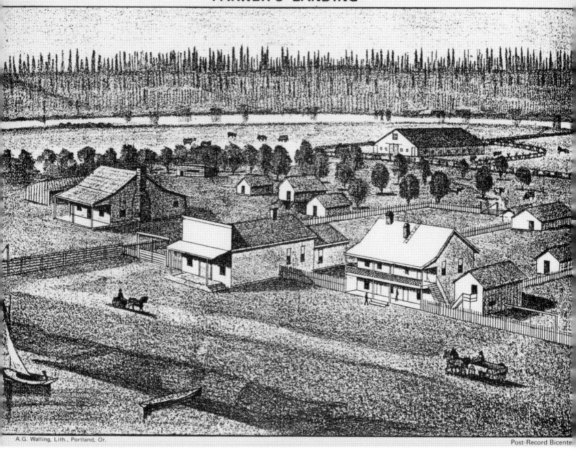

A.G. Walling, Lith., Portland, Or. Post-Record Bicente

David C. Parker

One of the founding fathers of the Camas-Washougal area, David C. Parker (1804–1858) did not live to see its settlement nor much of its growth. After traveling from Kentucky along the Oregon Trail, Parker and his wife and young children spent the winter in The Dalles, Oregon, awaiting the birth of their son George W. as others in the party moved on. The Parkers converted their wagon into a raft and, in January, floated the final leg of their journey. In 1845, basically as a squatter, Parker built a log cabin for his family in the unsettled area along the northern banks of the Columbia River. In 1850, his residence became official, as he received the very first Donation Land Claim, for 581.97 acres, recorded in Clarke County, Washington. As was customary at the time, half of the total claim was in his name and the other half in his wife, Anna's, name, so that the family could get more property. He cleared land to farm potatoes for the Hudson Bay Company store at Fort Vancouver. He also built a small dock called Parker's Landing on the Columbia River to receive supplies and accommodate riverboat travelers. He constructed the first sawmill and, with surveyor John Lowell, plotted out the new community of Parkerville, comprised of eight blocks on his eastern border. Lowell was paid with several parcels of land in the town for his services. Apparently unable to write his own name, Parker signed the deal with a witnessed "X." His untimely death left his land and his vision to his wife and children and the estate administrator, Lewis VanVleet (1826–1910). Parker's Landing Historical Park, adjacent to the Camas-Washougal Port Marina, commemorates David C. Parker and his Donation Land Claim.

Charles Warner Cottrell

C.W. Cottrell (1859–1944) is credited with being the first to bring electricity to the area. Cottrell got his start in Washougal in 1888 as a blacksmith, and he also built a sawmill on Mount Pleasant. There, he served as postmaster and was editor of a weekly paper, the *Mt. Pleasant Breeze*. He and his wife, Elizabeth "Lizzie" Fessenden Cottrell (1860–1942), were charter members of the Mount Pleasant Grange. After two years of operation, the Cottrell family sold the sawmill and home and moved to Washougal. He worked for a time at the Grange Store for H.H. Carpenter (1840–1920) before constructing a gristmill along the Washougal River in 1897. A dam was built upstream to power the machinery. The prospects of using waterpower for electric lights grew, and it was in 1910 that Cottrell and his son, Glen W. (1887–1974), threw the switch that brought power to Washougal. After their first dam and plant near the bridge at Seventeenth Street on the Washougal River, they built three more dams. Cottrell's Western Power & Light Company had the capacity of about 1,000 kilowatts and served homes and industries in Washougal and parts of Camas. He later sold to the firm to North West Electric Company, with customers numbering in the thousands.

Lewis VanVleet

Lewis VanVleet (1826–1910) made a Donation Land Claim in 1855 in the Oak Grove area of Fern Prairie. He donated an acre of land on the southwest corner for the Fern Prairie Cemetery. VanVleet represented the Clarke County area in the Territorial Senate from 1856 to 1859. He was appointed US deputy surveyor in 1856 and served an unprecedented two years working in the area. The work of a surveyor was extremely important for town development since property markers had often been large rocks, trees, or bends in a river. He was also administrator of David C. Parker's estate in 1859 and sold Parker's (1804–1858) 210-acre farm, which adjoined Parkersville, for the heirs. The buyer was Chas C. Stiles (1819–1874), who paid $1,110. Less than two years later, VanVleet bought the property from Stiles for $1,266 and used it to add eight more blocks to Parkersville, doubling its size. VanVleet had a home built on his land, which is now the site of Parker's Landing Historical Park in Washougal.

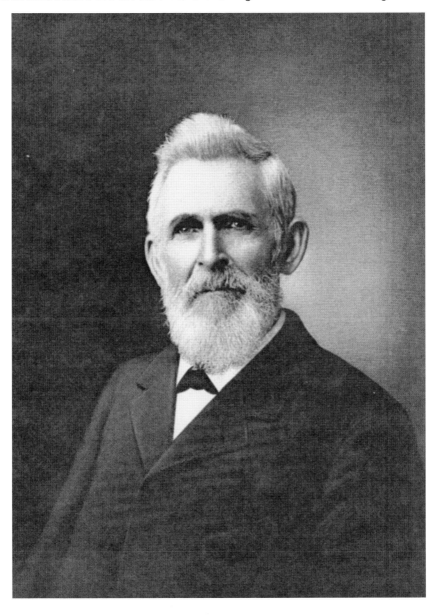

Fritz Braun Sr.

German-born Fritz Braun (1839–1917), who came to Parkersville about 1878, planned to open the first hotel and saloon in the town. He chose Parkersville to cater to the steamboats that landed there on their routes up and down the Columbia River, carrying supplies, produce, and passengers. However, before construction on his projects were completed, Braun saw that the nearby town of Washougal was more prosperous. He tore down what had been built and re-erected it at a new location. His establishment was called Park Hotel. In 1886, when Prohibition was being discussed, he proclaimed that, if it passed in the precinct, "all I would need to turn the bar into a drug store was a new sign," stating that he already had a stock of drugs on hand. He continued in the hotel business until about 1895, when he sold to Morris Webber (1856–1939). Beginning in 1895, Braun served as justice of the peace for four years. He was a notary public for 12 years, a school superintendent, and dealt in real estate.

J.E.C. Durgan Jr.
Although not its earliest settler, Joe Durgan (1827–1898) can be credited as the father of modern-day downtown Washougal. Durgan settled on a Donation Land Claim east of Parkersville in 1855, nine years after the arrival of David Parker. He later moved to Vancouver and ran a butcher shop, which burned down in a fire. He then farmed on Lady Island, returning to Parkersville in 1879, having bought a store from H.H. Carpenter. In 1880, Durgan and Lewis Love purchased 20 acres from Richard Ough to lay out the new town of Washougal, a mile and a half east of Parkersville. The first building in the new town was Durgan's home and store. The store was also the post office, and Durgan served as the postmaster. As businesses and settlers came to the area, they would build at this new, more convenient location, which is now downtown Washougal. (Courtesy of Rose Marie Harshman.)

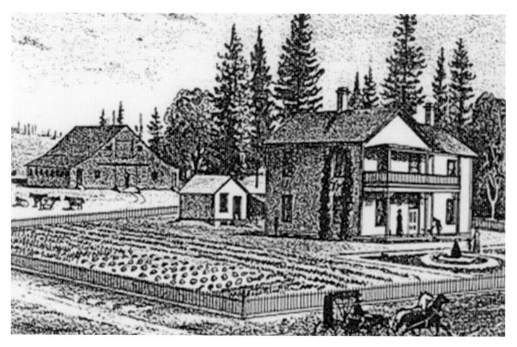

Joseph G. Gibbons

Joseph Gibbons (1797–1874) and his family were the second permanent settlers in the new Washougal district. They left Illinois in the spring of 1847 in a wagon train and arrived in The Dalles, Oregon, in early November. Gibbons sent his family ahead to Portland via boat, and he drove their cattle along the north side of the Columbia River in search of the right piece of property to settle on. He found a site at the mouth of a creek, known now as Gibbons Creek, about a mile and a half outside of present-day Washougal. His farm is pictured. They settled quickly, building a log cabin, growing potatoes and peas with seeds purchased from the Hudson's Bay Company, and starting the first sawmill in the area. Gibbons donated land for a school, which is now the site of the Orchard Hills Golf and Country Club clubhouse. Gibbons served on the first grand jury to convene in Clark County, on November 17, 1852. During the Indian Wars of 1855 and 1856, Gibbons and his sons Edward and Jacob served under Capt. William Kelly in the "Clark County Rangers," 2nd Regiment, Washougal Volunteers. (Courtesy of Rose Marie Harshman.)

Lewis Love

At the time of his death, Lewis Love (1818–1903) was considered one of Portland's premier self-made millionaires. He had a number of business endeavors, but one played a considerable role in the settlement and commerce of early Parkersville and LaCamas: captain of the steamboat *Calliope*. His 100-foot vessel made regular stops at Parker's Landing and transported settlers and produce up and down the Columbia River from The Dalles to Portland. Love also worked with Joe Durgan (1827–1898) in the plotting of Washougal to ensure it was set near deep water for porting ships.

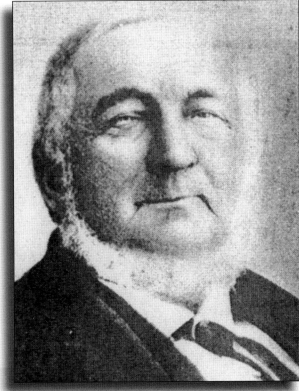

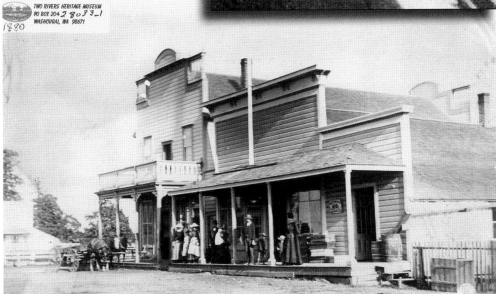

Al H. Kersey

One could say that Al Kersey (1850–1941) was in the right place at the right time and with the right skills. As the first carpenter to arrive in the new, growing community of Washougal in 1880, he built the first house, first store (pictured here), first church, first hall, and first schoolhouse. He lived and worked in a number of places locally throughout his life. In February 1940, Kersey was celebrated as the oldest resident of Camas, at age 90.

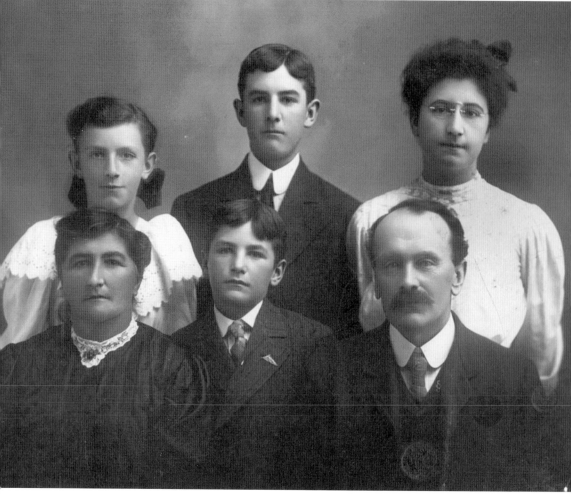

Albert Goot Sr.

The area around Camas's Goot Park, once a part of the Ough and Parker land claims, became a thriving dairy and farm thanks to the efforts of Swiss immigrant Albert Goot (1857–1946). The family name was originally Gut, meaning "good" in German. The family changed the spelling of its name to stop the joking at their expense. On the farm, the family raised potatoes, oats, and hay. The potatoes were shipped on riverboats to be sold in Portland. The Goot Swiss Dairy had a herd of 35 cows, which Goot milked by himself in the early years. A herd that size would take about four hours to milk twice a day, so he started his day early. Milk sold for 8¢ a quart. Family stories tell of Goot buying mules from the Camas paper mill and, on their first day of work for Goot, they abruptly stopped working when the mill whistle sounded at noon. The only way they would return to work was after they heard the second whistle, marking the end of lunch. Goot always ate at noon after that, whether he was hungry or not. Pictured is the Goot family. From left to right are (first row) Barbara Bertha Burkhart (1860–1937), Carl (1896–1984), and Albert; (second row) Emily, Peter, and Martha (1888–1982).

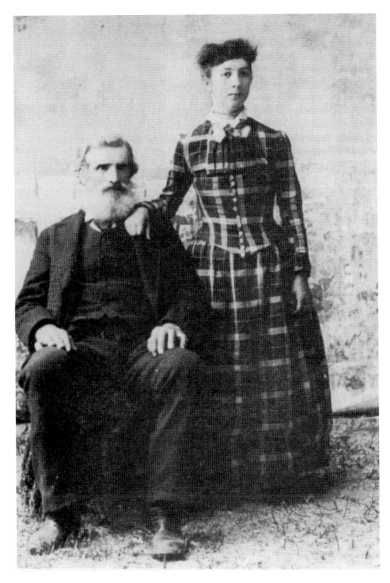

Thomas Watt Robinson Sr.
The namesake of Robinson Road in the Fern Prairie area of Camas, Thomas Robinson Sr (1830–1900), rode the Oregon Trail on horseback from Ohio. Traveling with good friend B.L. Gardner, it is said their horses were stolen by Indians near the Snake River. Continuing their journey on foot, Gardner's feet became so badly blistered that Robinson had to help him along and some times even carried Gardner on his back. Arriving in 1848 or 1849, Gardner took a 320-acre land claim, but Robinson continued to California in search of gold. After several failed attempts, Robinson took up his friend's offer to homestead 160 acres of his land claim. In 1893, he petitioned for a county road to be built along side his farm. Pictured here with his third wife, Johanna Christina Henk (1869–1931), the two were married in 1886 and had five children. Robinson also had five children by his first wife, Julia Etta Armstrong (1849–1880). She died soon after the birth of their last son, longtime Fern Prairie resident Thomas Watt Robinson Jr. (1880–1923). Critically injured in the back when a muzzle-loader fell and discharged, Robinson Sr. never completely recovered. The accident led to his death. (Courtesy of Rose Marie Harshman.)

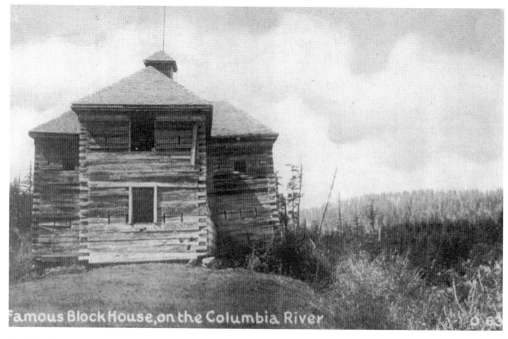

Famous Block House on the Columbia River

Reuben Riggs

Fort Riggs, a blockhouse and palisade defense structure (similar to the one pictured), was built during the area's Indian Wars of 1855–1856. It was named for Reuben Riggs (1804–1881), and was located on his land claim just east of Washougal on the north bank of the Columbia River across from the west end of Reed Island. Riggs, his wife, Sarah (1812–1912), and their five children made the dangerous journey here as part of a 150-person wagon train on the Oregon Trail. Reuben served under Capt. William Strong in Company A, 1st Regiment of the Washington Mounted Rifles and, later, was a corporal with Capt. William Kelly's Clark County Rangers. He suffered from paralysis for a number of years and was nearly entirely helpless at the time of his death.

Henry Harrison Carpenter

A native of New York State, Carpenter (1840–1920) was one of the first to open a store in Parkersville, in 1877. As a merchant, he provided a vital link between the farmers and loggers of the area and the goods and services they needed to exist. Before banks existed in the area, Carpenter was entrusted by locals to carry their cash for bank deposit on regular trips to Portland. A very reserved, yet very proud, gentleman, Carpenter was said to have not engaged in much conversation but enjoyed outings in his horse-drawn surrey, wearing a black silk hat. (Courtesy of Rose Marie Harshman.)

Roy Humphrey Dobbs

Roy Dobbs (1885–1973) is remembered for having worn several hats in the community, including farmer, banker, and mayor. He and his family arrived in Camas in 1908, coincidentally on the same riverboat as the O.F. Johnson family. Dobbs got his start farming Jersey cows east of Washougal on the original Gibbons land claim where, the current high school and Orchard Hills Golf and Country Club now stand. He bought a registered herd of cows back East and drove them across country, milking them along the way. In 1919, Dobbs became a cashier at Citizens State Bank in Camas, staying until it was sold to the National Bank of Commerce of Seattle in 1944. In the early 1930s, Dobbs served two terms as mayor of Camas and was known as a harsh chief executive, firing two police chiefs during his tenure. While mayor, he oversaw the very first street signs erected in Camas. Dobbs never left his farming roots, for many years operating a cattle and sheep farm (pictured) with Lawrence B. Johnston on Mount Pleasant.

Bede Buttler

Beda Buttler (1858–1930), when age 61, was the oldest worker at the Camas mill in 1919. A Swiss immigrant and brick mason by trade, he worked on the original mill foundation in 1884. With only 25–30 employees in those early days, he was said to have worked every job, from watchman to boss—that is, when the boss was sick. Buttler and his wife, Melanie (1857–1938), would often host mill managers for Sunday dinner and serve his renowned homemade wild blackberry wine. The Buttler homestead is today the site of Camas High School. (Courtesy of the Johnston family.)

Frances "Frankie" Braun Cheatham

Arriving in this world on March 17, 1881, Frankie Braun (1881–1970) had the distinction of being the first white child born in the city limits of Washougal. Daughter of Washougal pioneer and hotel owner Fritz Braun Sr. (1839–1917), the young Frankie enjoyed dancing in the hotel pavilion. Married in 1901 to Sam Cheatham, she joined him in the logging camps as a cook. A lifetime resident of the area, she was known for her kindness and, although not well off, she would never refuse anyone who stopped on her doorstep for something to eat.

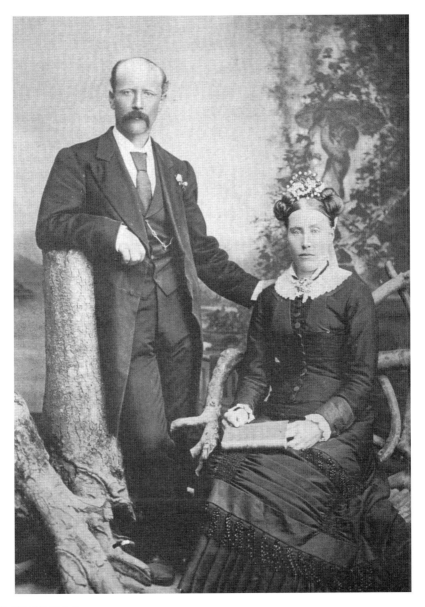

Peter B. "P.B." Erickson

The Mount Norway area of Washougal most likely got its name from the many Norwegian settlers who carved out homes and livelihoods there. Patriarch of the area's large Erickson clan, Peter Erickson (1846–1930; born Pedah Broch Ericksen) first farmed at Bear Prairie and, later, at the 80-acre homestead on Mount Norway. A large farmhouse was built in 1902, and a prune orchard was planted in 1908. The family also maintained a herd of dairy cows and, later, beef cattle. Tax receipts from 1894 showed payment of $18.33 for the farm's income. The family grew, and many members stayed in the Washougal area. At the 1946 Washougal High School graduation, four of Erickson's great-grandchildren were graduates: Arlene Erickson, LeRoy Burns, Ruby Robson, and Florence Brown. The Mount Norway property went out of Erickson family ownership in 1970. Erickson is pictured with his wife, Johanna (1846–1928). (Courtesy of Florence Wall.)

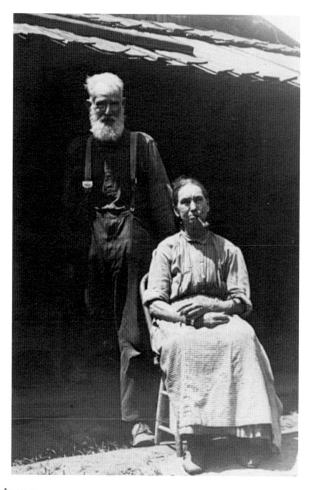

James Knox Polk Jones

Tennessee-born James Jones (1835–1917), his wife, Harriett (1838–1917), and their three sons arrived in December 1890 and settled just north of the Little Washougal River. Jones, a farmer, applied for a homestead in 1894, and his sons applied for homesteads adjoining his property to the north. After the family was forced out due to the Yacolt Burn in September 1902, two sons left for Portland. One son, Charles, remained. The nearby creek is named Jones Creek in their honor. James Jones was responsible for the main road from Fern Prairie to his popular picnic area on Jones Creek.

An incident involving Jones was reported in the *Vancouver Independent* newspaper of January 16, 1896:

> J.K.P. Jones, a citizen of Washougal, was held up about mid way of the long bridge over the Columbia slough Tuesday afternoon by two men. Jones stated he was riding quietly along on the bridge on his way home from Portland when two men wearing black calico masks on their faces, suddenly sprang up in front of him, and with pistols pointed at his head, demanded that he pass over his loose change. This he proceeded to do without wasting any words over the matter, except to request the privilege of sufficient change to get across the river. The robbers handed him back 25 cents and told him to make tracks and not under any circumstances look back. Jones did not stand on the order of his going but disobeyed the injunction about looking back after he had ridden about 100 yards. He saw the robbers climbing over the side of the bridge to the ground.

CHAPTER TWO

Community Builders and Historians

The heart and soul of Camas and Washougal were created by dedicated citizens who gave of their time, money, property, and vision to create strong government, civic organizations, and churches, and who preserved the area's history and local culture.

The area's civic leaders have provided a foundation for a prosperous future. Community leaders, such as the first mayor of Washougal, Morris Webber; beloved Camas fire chief Lawrence Beauchamp; and Camas's first city administrator, Lloyd Halverson, are examples of dedicated civil servants who helped set a successful course for the area's future.

The efforts by many past residents have resulted in the quality of life enjoyed in the community today. J.D. Currie Youth Camp, the namesake of Camas lawyer John Currie, continues to welcome groups of young people to explore nature. The surprising and significant monetary gifts from local residents, like Christine Kropp and Ray Hickey, provided the funds for community facilities, and schools.

Historians Vincent Ast, Curtis Hughey, and Betty Ramsey worked tirelessly to protect and share the rich history of the area and its people. History lover Roger Daniels is credited with bringing the notoriety the area deserved for its historic connection to the Lewis and Clark Expedition. Their efforts, along with others like them, have ensured that the unique heritage of Camas and Washougal will not be lost. The individuals featured in this chapter were dedicated to the communities they love and call home.

Morris Webber

It was on November 7, 1908, at Surber's Store in Washougal, that an election took place regarding the town's incorporation. There were 76 votes cast. At the same meeting, Morris Webber (1856–1939) was elected the town's first mayor. Webber was a pioneer who worked as a dairyman on the Goot and Gibbons farms and later managed a saloon while his wife, Bertha Barbara Burkhart (1863–1938), manned the hotel. In 1902, Webber bought some land near town and built his home. It was there that he and other investors started the Columbia Condensed Milk Company. A deep well with a storage tank was installed, which later became the center for the Washougal water system. Around 1911, Morris leased the whole of Lady Island to raise his family and operate a dairy, milking 30 cows by hand. (Courtesy of Dorothy Durkee.)

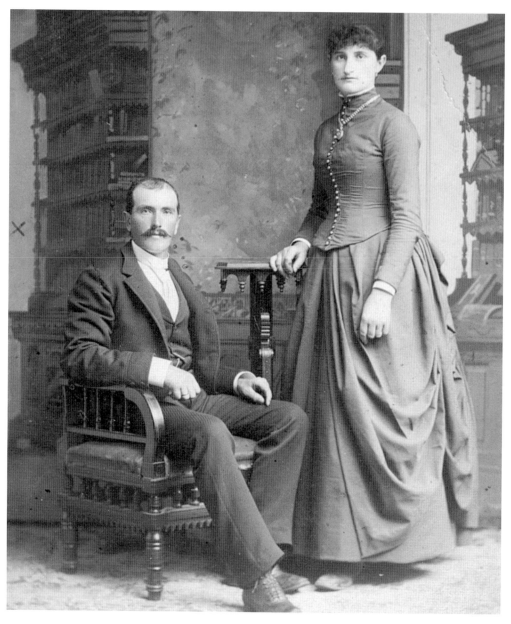

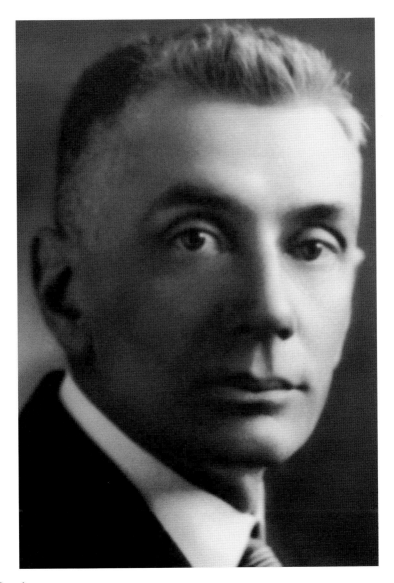

John D. Currie

Having stopped in Portland with his regiment after the Spanish-American War in 1899, young lawyer John Currie (1873–1951) vowed to return to the area. In 1911, he and his wife, Alice (1881–1968), traveled throughout Oregon and Washington to find a place to start his law practice. They arrived in Camas on a 100-degree July 4, when the town was filled with activity and a parade. He immediately wired his folks to tell them he and Alice had chosen to make this town their home. Currie was elected city attorney that year and was an important player as the city extended its boundaries. A visionary who was called rather ambitious, Currie recognized the town's potential, with its proximity to railroad, waterways, highways, its abundance of electrical power, and its nearby market. He also saw the need for organizing a port district. Through his love of the outdoors and young people, and in consequence of the loss of his young son, Billy, Currie, in 1924, obtained a charter to organize a lodge for the Boy Rangers of America for children too young for the Boy Scouts. In 1945, Currie leased land from Crown Zellerbach for $1 per year and began work on a lodge. The camp, located on the north shore of Lacamas Lake, bears his name and continues to serve area youth.

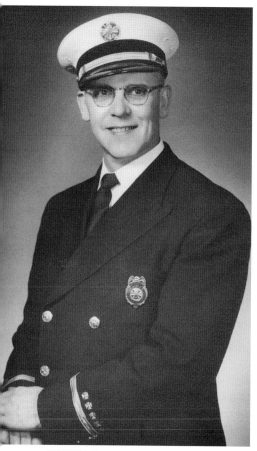

Lawrence Beauchamp

A longtime resident of Camas, Lawrence Beauchamp (1905–1996) had a lasting impact on the safety and growth of Camas-Washougal and Clark County. Beauchamp was a well-respected Camas fire chief from 1949 until 1960. As a young man, he remembered the 1923 fire in downtown Camas that led to the organization of the town's fire department. He was a charter member of that first volunteer group. Beauchamp had a leadership role in Safety Unlimited, a group of local organizations that worked to identify and correct safety problems in industry. He helped set up similar groups in the state and spoke about his work at safety gatherings throughout the region. For that work, in 1956, Washington governor Arthur Langlie presented Beauchamp with the Industrial Safety Conference's top award. In the 1950s, he was instrumental in the development of the CAROL program, which coordinated local service groups so no one was missed when Christmas baskets were provided for families in need. After retirement from the department in 1960, he went on to fight fires of a different type as a Clark County commissioner. It was a time of immense and rapid growth in the county, and Beauchamp successfully managed funds to keep services growing without creating huge county debt. As a commissioner, he was also instrumental in negotiating the gift of 300 acres from Crown Zellerbach for what is now Round Lake Park. (Left, courtesy of Shirley Gilmer/Alan Stoller.)

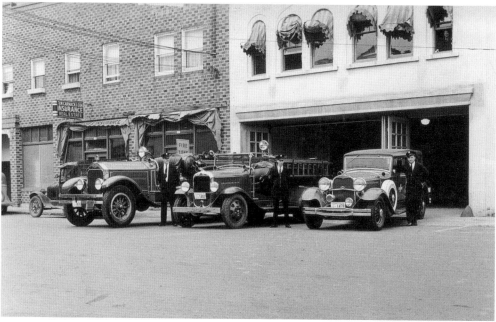

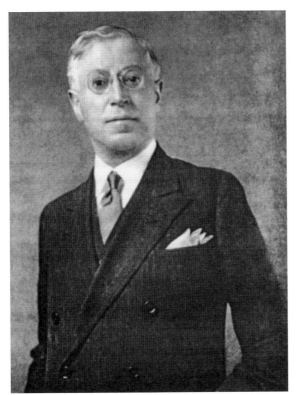

Louis Bloch

Louis Bloch (1875–1951) had a humble start in the paper industry in 1889, tying up bundles of paper bags for the Crown Paper Company in San Francisco. Through the early 1900s, he worked his way to general manager and vice president positions and had a large role in negotiating a number of mergers that would affect the mill in Camas. Bloch was chairman of the board of Crown Zellerbach Corporation in 1940, when a donation of land was made to the City of Camas for the Louis Bloch Park.

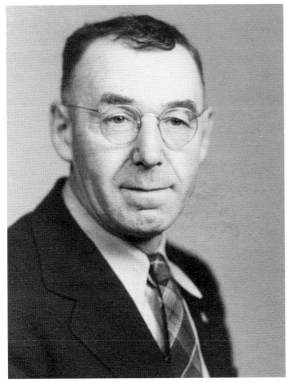

Joseph Ast

Joe Ast (1885–1958) was a leading force behind the establishment of a Public Utility District (PUD) in the Clark County area in 1938. He was elected to the board at its inception and served as a commissioner for many years. Ast served for all but one and a half years in the period from 1938 until his death in 1958. At that time, he was vice president of the PUD Board of Commissioners. Ast came to Camas with his family as a young man in 1904. (Courtesy of Clark Public Utilities.)

29

Vincent Ast

Vincent Ast (1914–1992) could not have foreseen that his love of history would make him a part of history. After his retirement from the Camas mill with nearly 50 years of service, Ast was involved in many community service organizations. Some of his most significant work was with the Camas-Washougal Historical Society and the creation of the new museum in the basement of the Camas Library. He also worked toward the preservation of the historic Parkersville site. For this work to save and share local history, in 1987, Ast was the second person to receive the honor of Camas Citizen of the Year.

Nan Henriksen

Not only was Nan Henriksen (b. 1941) the first woman mayor of Camas, her vision and planning prepared the city for positive growth and economic strength. Her terms in office ran from 1983 to 1992. One of her proudest accomplishments, against all odds, was the creation of a light industrial park in west Camas. Anchored by such companies as Sharp Microelectronics and Underwriter Laboratories, the park was initially seen as a gamble, but it has brought new industry and considerable jobs to the area. Henriksen also helped create the Crown Villa Apartments to provide affordable elderly housing, set aside local green spaces, and brought the Camas Community Center into existence. In addition to her work as mayor, Henriksen owned and operated Save-on Drugs/Nan's Hallmark from 1976 to 1990. Her greatest acknowledgment came in 2006, when she was named Political Leader of the Century by the Camas-Washougal Chamber of Commerce. (Courtesy of Nan Henriksen.)

Alfred Omega Hathaway

Residents of Washougal associate the name Hathaway with an elementary school and a park, both of which owe their existence to a donation of land by Alfred Omega Hathaway (1864–1956). Hathaway and his twin brother were born to a Clark County pioneer family. In 1902, he and his wife, Lucy (1870–1947), acquired several hundred acres in Washougal that had been a part of the Stiles Donation Land Claim. They made a gift of land in 1910 for a two-story, eight-room schoolhouse and the creation of the Hathaway Free Auto Park, north of the school along the Washougal River. They also donated land for the Washougal Methodist Church and helped greatly with the cost of its construction. Hathaway worked as a dairy farmer until 1921, when a blackberry thorn lodged in his thumb led to an infection that caused the loss of his hand and forearm. Unable to farm, he turned his sights to his landholdings and began selling lots. He started A.O. Hathaway Real Estate, which continued to operate until shortly before his death. Adding to his legendary status, he and his twin brother, Alpha Beebe Hathaway (1864–1959), lived to be named the oldest twins in the state of Washington, at age 91.

Roger Daniels

Founder and cochair of the East Clark County Lewis & Clark Bicentennial Committee, Roger Daniels (b. 1950) can be credited with preserving and bringing notoriety to Washougal's connection to the famous expedition. After extensive research on the Corps of Discovery's accomplishments during their six-day encampment along the shores of the Columbia River in Washougal, Daniels wrote an article for *Columbia* magazine. The article brought attention from state, regional, and national bicentennial planning committees. Asked to name the previously unnamed historic campsite, his research led him to recommend "Provision Camp," which was accepted. Daniels then worked with port, county, and city leaders to turn the area into a regional park. Again he was asked to provide a name, recommending "Captain William Clark Park." On a trip to the University of Virginia for the kick-off of the Lewis & Clark Bicentennial in 2003, he met direct descendants of William Clark. When they heard that a park would be named for their forefather, they made plans to attend the dedication. They also commissioned a bronze sculpture copy of the bust of William Clark that rests over his grave in St. Louis. The bust copy is on display in Washougal City Hall. Daniels was appointed by Gov. Gary Locke to serve on the statewide Lewis & Clark Bicentennial Advisory Committee and was chair in 2006. A 1968 Washougal High School graduate, Daniels worked 27 years in education and is a member of the Clark College Alumni Hall of Fame. He is an active member of the Washougal community and a strong supporter of public education. (Courtesy of Roger Daniels.)

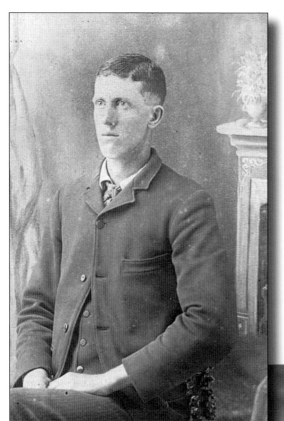

George Perry Dibble

A former postmaster from Oklahoma, George Dibble (1870–1953) was a three-term mayor of Washougal. He first came to the area in 1888, but did not stay long. He returned in 1907 and bought a half-interest in a general mercantile business, which he operated until 1920. Dibble then engaged in farming until he returned to retailing and took over the Washougal Feed Store. He retired in 1942.

Christine Kropp

It was a surprise to seven local nonprofit organizations when, two years after the death of Christine Kropp (1905–1998), they learned they would share equally her $2.45-million estate. Kropp, who never married, worked as the executive secretary to a variety of paper mill managers over 42 years. At the suggestion of one mill manager, Kropp learned about investing, even taking the bus to Portland for classes in finance and economics. She enjoyed the challenge of investing. As her health declined, Kropp's portfolio made its most significant gains. She never knew its ultimate value.

Theodore Jenny
Ted Jenny (1893–1984) served more than 20 years on the Washougal City Council and later as mayor (1942–1948). Among memorable contributions were his involvement in the reconstruction of a new bridge between Camas and Washougal after the first burned down, rejuvenation of the City of Washougal Cemetery after its purchase from the Odd Fellows Lodge, and closing the streets of Washougal and authorizing a street dance in celebration of the end of World War II. During the war, Jenny worked as an inspector for housing constructed for workers at the Vancouver shipyards. He was given extra gas rations to make the daily trip from Washougal. Jenny also worked as a millwright at the Pendleton Woolen Mills for more than 20 years. In January 1950, he and his brother Thomas (1890–1973) formed Jenny Brothers Block Co. in Washougal. Jenny retired in 1958. (Courtesy of Millie Knapp.)

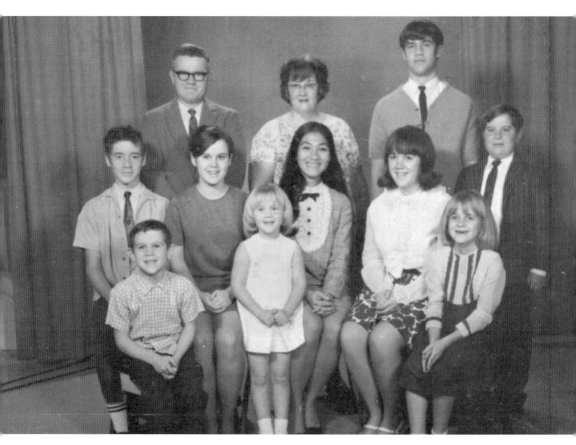

George and Lois Guard

The Guard family name is synonymous with community service, due in large part to the example set by family patriarch George Guard (1923–1998) and matriarch Lois Horning Guard (1925–2009). The lifelong residents of Camas and Washougal, married for 51 years, owned Columbia Litho for 35 years. At first, they partnered with Tom and Alice Blair, and then the Guards became the sole owners. In 1987, they sold to their son Pat, who still operates the business in 2013. The Guards made it a point to return what the community had given them. George was active on Washougal school levies, and, during the 1970s, he served on the school board and was chairman of the board. He also volunteered with several civic organizations, including the Knights of Columbus and the Elks; he coached Little League, umpired Babe Ruth baseball, and was a longtime member of Orchard Hills Country Club. Lois, too, was a part of many organizations and community activities. For more than 20 years, she wrote a weekly column for the *Post-Record* titled "Guarded Comment." She, like her husband, served on numerous civic groups including Women's Club, Catholic Daughters, and for many years gave presentations to Washougal High School business classes. Lois also was a driving force in the establishment of the Little League softball program that allowed local girls to play. Together, Lois and George supported the chamber of commerce and American Field Service (AFS) student exchange program. The Guards raised eight children and hosted AFS student Lan Le from South Vietnam in 1966 (pictured with the family). Later, during the Saigon airlifts in the mid-1970s, they helped to sponsor Le's family as they fled. George and Lois's large family was their pride and joy, and all of their children carried on the family tradition of civic service by serving and leading in local groups and government. The children are proud of the fact that, after George passed away, they organized a golf tournament in George's memory and raised more than $110,000 over several years. All proceeds were donated to local school foundations, sport groups, and regional charities. (Courtesy of the Guard family.)

Curtis Hughey

The driving curiosity and love for history of Curtis Hughey (b. 1929) has resulted in a priceless culmination of historic Camas and Washougal information. Hughey, whose mother was born and raised in Camas, came to the area in 1946 to live with his grandparents and graduated from Camas High School that year. He was active in civic work and was involved in starting the Fern Prairie Fire Department. Hughey retired from the Camas paper mill in 1991 and began genealogy research. This work led to two books using excerpts from local newspapers written by and about local people: *The Good Old Days, 1877–1906* and *Good Old LaCamas News, 1887–1892*. In addition, Hughey organized volumes of homestead paperwork and testimony for every homestead from Cape Horn to 192nd Street in East Vancouver. Hughey led the Camas-Washougal Historical Society as president for 16 years, until 2012. He is the person everyone calls on for answers when researching local history. (Courtesy of Rene' Carroll.)

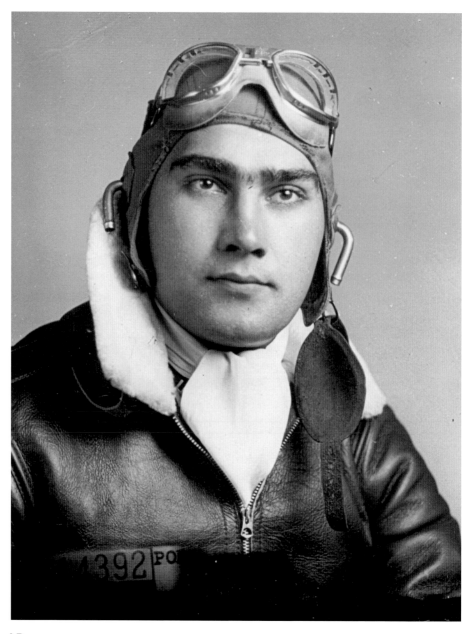

Paul Baz

Through his work on the board of the Camas-Washougal Historical Society and 17 years on the City of Camas Planning Commission, Paul Baz (1922–1994) demonstrated his love for the past and future of his community. A lifelong Camas resident, Baz used his knowledge of the area and his keen ability to remember people to create a successful 45-year career in real estate. He also proudly served in the US Air Force during World War II, flying transport missions. He retired as a lieutenant colonel in the Air Force Reserves. Just a week before his death, he and his wife, Belva, were honored for their donation of 18.78 acres of land to the City of Camas in 1986. This generous gift set in motion the Washougal River Greenway, which now provides the community with access along the river's edge, via scenic paths and over bridges. (Courtesy of Belva Baz.)

Belva Baz

A volunteer who gave so much of herself, Belva Baz (b. 1923) spent 42 years asking others to give as well. Give blood, that is. Baz started volunteering for the American Red Cross at the Camas paper mill in 1964. She worked as a secretary there and later at the Crown Zellerbach Central Tech Research Lab. Her first duties for the Red Cross included typing blood-draw registration forms and organizing donors at the mill. In time, she became responsible for the coordination of blood drives throughout Camas, Washougal, and east Vancouver. Described by Red Cross officials as "a true lady and completely reliable," her drives were well organized and ran smoothly. Baz, now in her 90s, continues to give of herself. She knitted and donated 44-dozen baby caps and is now creating knitted caps for cancer patients. In addition, she volunteers two days a week at her daughter Penny's elementary school classroom. (Courtesy of Belva Baz.)

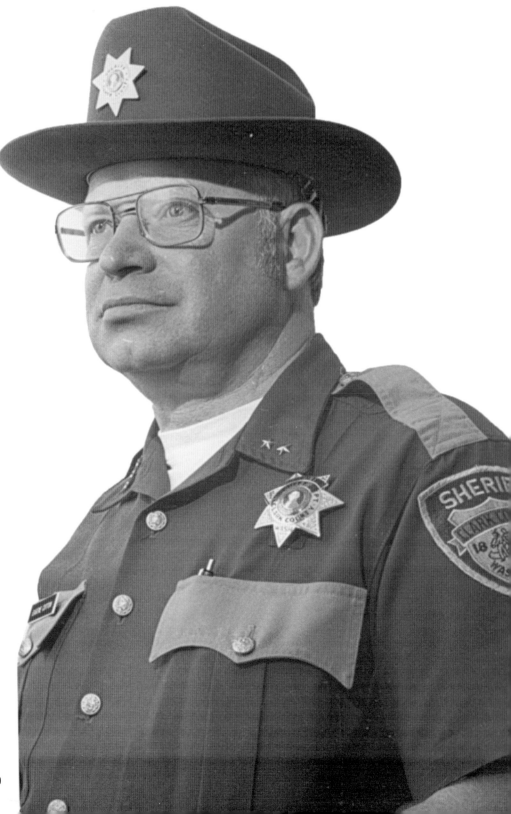

Eugene Cotton (OPPOSITE PAGE)
Clark County sheriff and Washougal resident Eugene Cotton (1928–2008) began his career in law enforcement in 1955. He won the election for sheriff, taking office in January 1971. He was considered by many to be a forward thinker. This foresight was demonstrated by his prediction of rapid growth in Clark County in the early 1970s, convincing the county commissioners to nearly double the police force. He also improved officer professionalism by increasing training. Cotton established an emergency call system, which was the precursor of the county's 911 service, as well as a drug-and-vice unit that won statewide acclaim as the "finest narcotics-fighting organization anywhere." Cotton stayed in touch with his department and the public, encouraging citizen involvement and creating the Explorer Scout program. (Courtesy of Jon Cotton.)

Bernice Pluchos
The Camas-Washougal Historical Society (CWHS) was created in part to help prevent commercial development of historic Parkersville. The first meeting in 1978 was held in the Washougal living room of Bernice Pluchos (b. 1929). The community enthusiastically supported the new organization with donations of funds and artifacts so much so that Pluchos worked with others to open a museum in the basement of the Camas Library. What followed was the Two Rivers Heritage Museum in Washougal. A founding member and first president of the CWHS, Pluchos was an active volunteer for 35 years and the organization's newsletter editor for 30 of those years.

Ralph Hootman

Washougal's "Mr. Fourth of July" was as eruptive as the local fireworks tradition he originated and raised funds for. A mayor in the early 1970s, Ralph Hootman (1916–1979) was said to have tackled city issues with vigor and bombast. Although he had a short fuse, he was wise enough to request advice from his cool-headed city council.

Wes Hickey

Husband, father, entrepreneur, and executive Wes Hickey (b. 1958) has committed time, capital, and imagination to the rejuvenation of downtown Washougal over the past decade. Hickey founded Columbia Resource Company and Finley Buttes Landfill Company in 1989, partnered with Sterling Investment Partners in the acquisition of Tidewater Holdings in 1996, and founded Lone Wolf Investments in 1999. His efforts in Washougal have focused on reestablishing the historical core of the city as an active and vibrant gathering place that also serves as a source of local pride and helps to create a unique identity for the town, which calls itself "The Gateway to the Gorge." (Courtesy of the Hickey family.)

Roger Malfait

A lifelong member of the Washougal community, Roger Malfait (1929–2000) was honored by his family with the donation of 47 acres of land near the Washougal River in his name. The land once owned by Malfait is now a park for use by the nearby Cape Horn–Skye Elementary and Canyon Creek Middle Schools and the Washougal River community. The area features a track, trails, and salmon restoration efforts. Malfait, known as a likable and very honest person, founded Hi-Way Fuel in 1952. But the business was not his greatest love. He retired relatively young in 1970, selling the business to his son Scott in order to pursue farming. For 22 years, he and his wife, Loretta (1932–2010), worked a 165-acre ranch with 150 head of cattle. During the winters and when ranching chores were complete, Malfait spent time selling real estate and buying, remodeling, and selling homes. He worked on a total of 38 project houses. (Courtesy of Scott Malfait.)

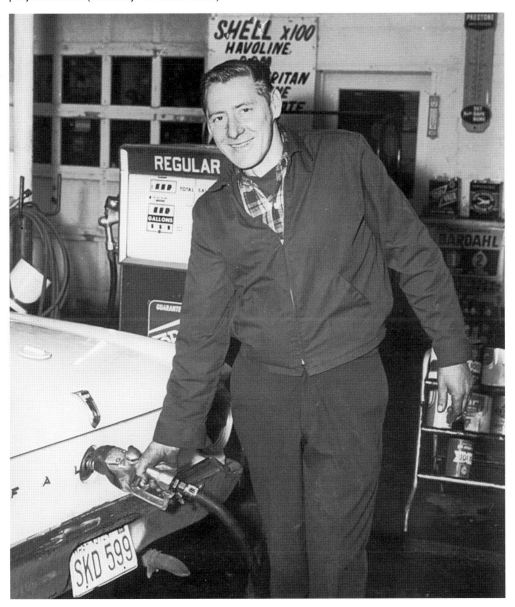

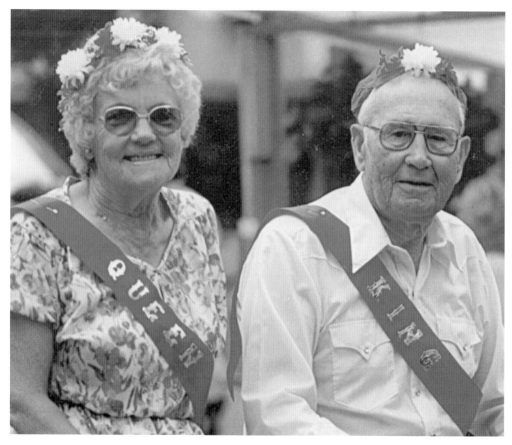

Earl F. and Fae Miller

With an entire community to choose from, the honor of being named the very first King and Queen of Camas Days was given to Earl (1901–1989) and Fae Starks Miller (1907–2002). Earl was a 1920 Camas High School graduate, and Fae graduated in 1926. Both were very active in numerous civic organizations, including the creation of the Camas-Washougal Wildlife League. A retired carpenter and past president of the Carpenter's Union, Earl's work can still be seen in the many homes he built and repaired throughout Camas. He also served on the Camas Planning Commission for 32 years. Fae, a lifelong Camas resident, was active in the Navy Mothers, was state president of the Ladies Carpentry Auxiliary, and was a member of the Washington State Pioneers. Both were known as caring, giving individuals. (Courtesy of Maxine Miller Ambrose.)

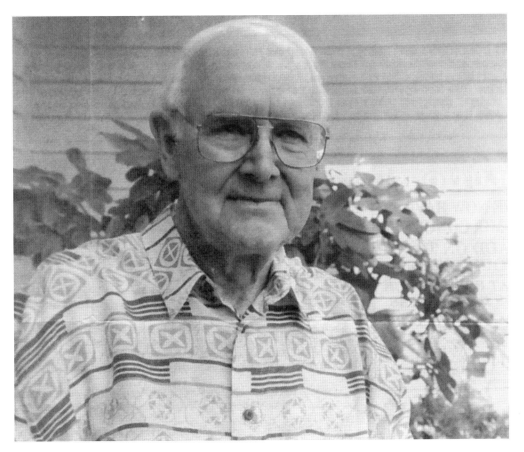

Fred Weakley
Fred Weakley (1913–2002) was a well-known and highly respected member of the community. He farmed 150 acres near Lacamas Lake for many years and was the first to import Brahma cattle to the area. Weakley was elected to two terms as Clark County commissioner in the 1950s. During his tenure, he spearheaded the dredging of the China Ditch, which enabled clean water to feed into Lacamas Lake. In 1960, he was hired as the first manager of the Port of Camas-Washougal. Under his leadership, the port built the 5.5-mile dike along the banks of the Columbia River, which enabled the facility to construct its highly successful industrial park and the Steigerwald Lake National Wildlife Refuge. Weakley was named Camas-Washougal Citizen of the Year in 1995 in honor of his lifetime of service. (Courtesy of Gail Weakley Gregg.)

Elizabeth Ann Ramsey

Director of the Two Rivers Heritage Museum for more than 14 years, Betty Ramsey (b. 1928) led the effort of taking a scattered collection of artifacts and documents donated to the Camas-Washougal Historical Society and organizing and displaying them in the new museum space. She had no formal museum training, but worked hard, read books, visited other museums, and learned functions, such as accessioning, by trial and error. She helped volunteers begin recording oral histories from some of the older residents and also put into place a process to clip and save information on local families, such as obituaries, wedding and birth announcements, awards, and feature stories from the *Post-Record*. This book could not have been assembled without the clippings she diligently saved and organized. Ramsey also had a knack for creating interesting displays of artifacts. She learned the skill in her youth. The daughter of a grocery store owner, she would often create displays of the store's weekly specials. Her husband, Don (b. 1924), an active volunteer as well, has been a constant support during their more than 60 years of marriage. Ramsey also gave of her time to Girl Scouts, Soroptimist International of Camas-Washougal, and many other local service organizations.

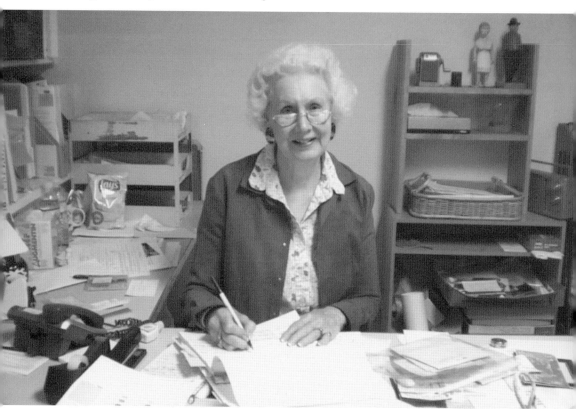

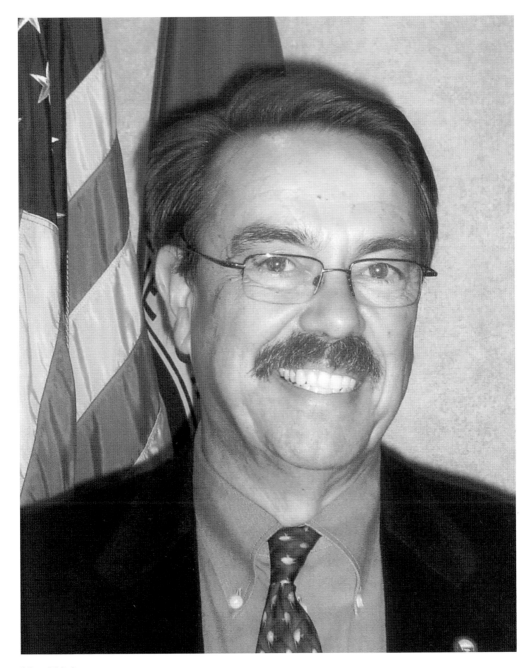

Lloyd Halverson
As Camas's very first city administrator, Lloyd Halverson (b. 1947) provided leadership and vision from 1989 until his retirement in 2013. Halverson's greatest legacy is perhaps the more than 35 parks and large open-space projects that total approximately 620 acres. For these projects, he planned, acquired funding, obtained the properties, and led their development. During his career, he received upward of $50 million in grants, $50 million in direct appropriations, and more than $100 million in favored loans. Halverson, who served as an active member and leader on numerous commissions, associations, and boards, believes that every person can make a positive difference. (Courtesy of City of Camas.)

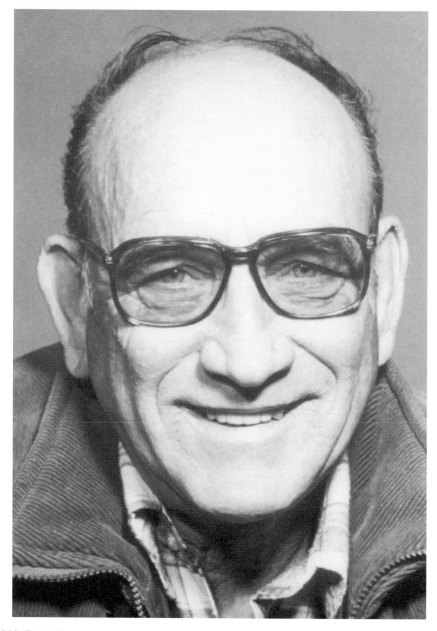

David H. Daniels

Dave Daniels (1922–1993), a longtime Clark County Public Utilities District (Clark Public Utilities) employee, was known locally as "Mr. PUD." While serving as the district PUD engineer for Camas-Washougal, Daniels designed the high-voltage power service to the newly created Port Industrial Park, constructed in the 1960s. Daniels also contributed through his two terms as Camas-Washougal port commissioner. First elected in 1985 and reelected in 1991, he was influential in a number of economic gains made by the port. Daniels led efforts to pave and light the Grove Field Airport runway. His easy manner also helped him to facilitate compromises between pilots and landowners near Grove Field airport in the 1980s. Daniels supported the creation of the Parker's Landing Park Advisory Committee, which led to the preservation of the Parker's Landing Historical Site. (Courtesy of Roger Daniels.)

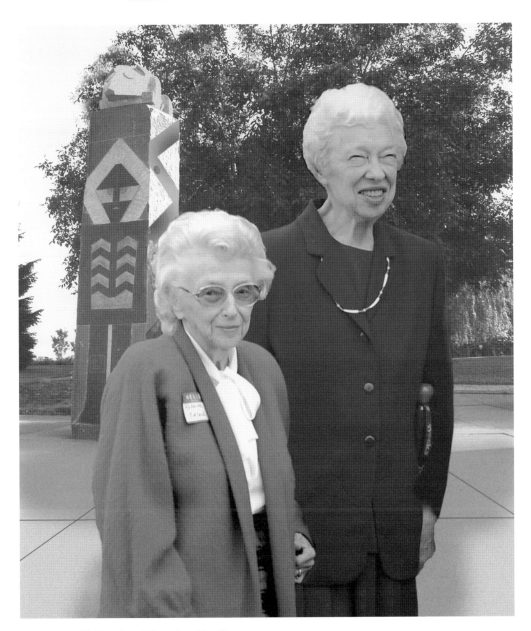

Roberta J. Tidland and Rosalee MacRae
Roberta Tidland (b. 1925) and Rosalee MacRae have battled far beyond the mundane of commercial imperatives. Together with others, these guardians of local heritage saved the last undeveloped piece of land, the site of historic Parkersville, which was the first point of American pioneer settlement in the Washington Territory. In 1978, commercial development threatened the Columbia River landmark. Even after the old Van Vleet home mysteriously burned to the ground, they knew that preserving the area was still vital. After years of working with government officials, fishermen, and businessmen, Tidland (left) and MacRae saw the realization of Parker's Landing Historical Park, a small, lovely park with winding paths, shaded areas, and benches to sit and reflect. Gazing toward the river, visitors can almost experience what early settlers saw as their new homeland. History is her-story, too. (Courtesy of Dale Tidland.)

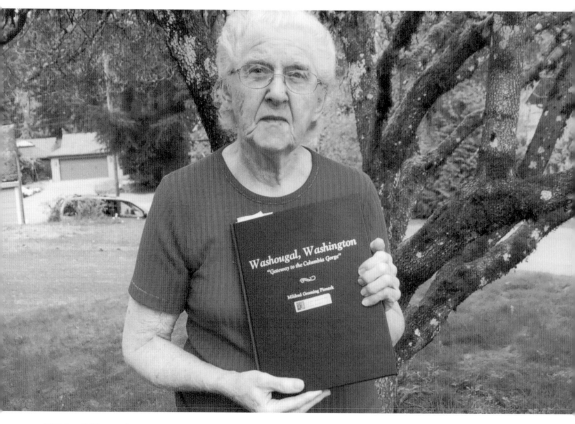

Mildred Piontek

The Camas-Washougal Historical Society got its start in 1978 with the help of charter member and longtime volunteer Mildred Piontek (b. 1927). Working side by side with her husband of 57 years, Herman (1915–2002), Mildred enjoyed preserving local history. Herman helped save a grand piano with Washougal ties when he and two other men picked it up in Sequim, Washington, just days before the residence where it was found burned to the ground. The piano remains on display at the Two Rivers Heritage Museum. Using a vast collection of newspaper articles about local residents saved by Dophe Gilbreath (1910–1994), Mildred edited the book *Washougal, Washington: Gateway to the Columbia Gorge*, to preserve and share those stories. In addition, the Pionteks were honored with a plaque mounted at the Columbia Gorge Interpretive Center, commemorating their work there. (Courtesy of Rene' Carroll.)

Jesse "Bill" E. Hamllik
The City of Washougal recognized the service of five-term councilman Bill Hamllik (1906–1992) by naming a local park after him in the mid-1980s. Hamllik came to the area in the 1920s and worked as a cobbler in his father's shoe repair shop in Washougal. He later worked as a clerk for the postal service. Hamllik, a strong advocate for the citizens of Washougal, also served on the parks board for many years. Bill Hamllik Park is located at 4285 Addy Street. (Courtesy of Tami Hamllik Malone.)

Winnie Shinn
Readers of the *Post-Record* newspaper in the 1960s and 1970s came across the words of Winnie Shinn (1915–2005). Hired as a proofreader in 1964, Shinn moved up to the position of women's editor and wrote in-depth features about the people of Camas and Washougal. Her weekly column, "Shinnanigans," delighted readers with whimsical rhymes, social news, and witty observations from her husband, which she prefaced with "Hub says . . ."

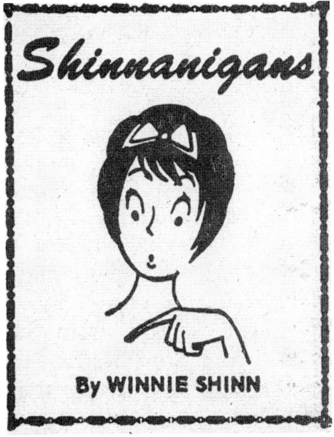

Lonnie Belz
At the time of his death, Lonnie Belz (1898–1996) was the last remaining member of the first Camas Volunteer Fire Department. The department was started in early 1923 when a blaze destroyed several buildings in unprepared downtown Camas. It was a grim irony when, in 1936, Belz and his fellow volunteers fought a fire that destroyed his parents' home on Prune Hill. Belz was a major force behind the creation of the Camas Cemetery Association, a self-funding group that took over maintenance of the cemetery for more than 80 years before its care returned to the city. He and his wife, Lovday (1900–1973), were very active in Boy Scouts. One of his major accomplishments was work on the J.D. Currie Youth Camp on Lacamas Lake. .

Richard "Dick" Beaver

It was a surprise when longtime resident and long-serving Washougal council member Dick Beaver (1913–1986) was honored with a namesake park, at 1200 A Street. Beaver was a member of Silver Star Search & Rescue and was responsible for construction of its headquarters in Washougal. Beaver Park held a T-ball field until the 2003 construction of the Washougal police station reduced its size. It is now designed to attract winged wildlife and features flowering plants and habitat vegetation for visitors to enjoy. (Courtesy of City of Washougal.)

Alice Gee

A charter member of the Camas-Washougal Historical Society in 1978, Alice Gee (1921–1996) served on the board for 18 years and worked as secretary for 15 years. A retired Camas teacher, Gee's volunteer work extended to other organizations focused on the preservation of history, including the Parker's Landing Park Advisory Committee, Clark County Heritage Trust (charter member), and several area bicentennial planning committees. Gee was known for not speaking up often and gave issues much thought. When she had something to say, people would stop and listen, because she was usually right.

Mabel Pickett

A lifetime resident of Camas, Mabel Pickett (1910–2009) loved history and left a legacy of great stories. At a young 16 years of age, Pickett worked for the Pittock and Leadbetter families in their Camas home, Fern Lodge, which her father, Severt Ostenson, built. She did housework, cooked meals, and was even a chauffeur, driving their 16-cylinder Cadillac. She also worked in Portland as one of the first models of the new permanent-wave hairstyles. In 1932, she married millworker Sidney Pickett (1910–1988) and, when the Depression hit, lived with her parents. The whole family survived on just 24.5¢ a day. Living to the age of 98, Pickett was considered an expert on the people and events of early Camas.

CHAPTER THREE

Business Leaders and Professionals

The communities of Camas and Washougal are products of industry. Henry Pittock established his paper mill in Camas, and Clarence Bishop and his family operated a woolen mill in Washougal. The steady jobs they created provided the basis for other commerce to follow.

The early business leaders of Camas and Washougal impacted the community far beyond their storefronts and the services they provided. The merchants were often the civic leaders, responsible for the creation of governments, service groups, and churches. These respected citizens provided the products, services, and jobs, as well as a vision, to help growing towns flourish and prosper.

O.F. Johnson, who opened the first bank in Camas, took great financial risk and provided a vital service to the growing area. Arnold Surbeck's grocery store was a Washougal institution, serving customers for more than 40 years. The Runyan family's Runyan's Jewelry and the Guard family's Columbia Litho are two of several businesses in the area that carry on the strong tradition of customer service over generations. Through the knowledge and hard work of individuals featured in this chapter, businesses and industries have continued to grow in Camas and Washougal.

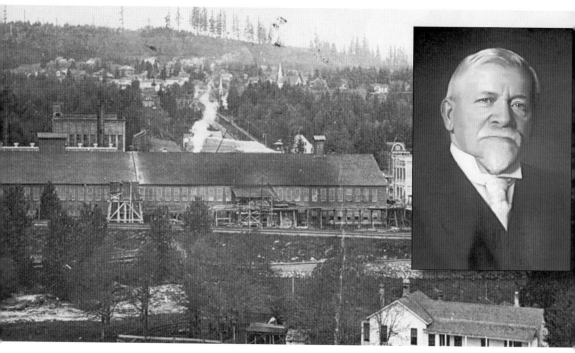

Henry L. Pittock

Henry Pittock (1835–1919) arrived in Oregon in 1853 and was hired by Thomas Dryer at the *Weekly Oregonian*. He worked as a printer, mailed and delivered papers, and rose to the position of shop foreman. Rather than pay him wages, Dryer made Pittock a partner. In 1860, Dryer mortgaged the paper to Pittock. It was then that Pittock created the six-day-a-week *Morning Oregonian*. Pittock wanted the newspaper to be different from others. He sought to emphasize news over opinion, deliver more timely information, and be less political. As the paper's circulation grew, so did his need for newsprint paper. So, in 1883, Pittock and a group of investors purchased a large area of land at the new settlement of LaCamas to start the Columbia River Paper Company. The town was then platted with the mill at its western end. In May 1885, Pittock's first paper was produced. The paper mill, however, burned down in 1886. The company rebuilt and began production of straw paper in 1887. Once Pittock had new machinery installed in 1888, white paper began to be produced. Pictured is the mill in the early 1900s.

Doran H. Stearns

Representing Henry Pittock's interests in the new town of LaCamas, Doran Stearns (1841–1909) negotiated the purchase of the land needed to establish a paper mill there. Among the property he acquired was the mill site in town and land up a creek and around the nearby Lacamas Lake for control of the water supply. Stearns set his own roots in the community and applied for a homestead in 1883 of 96.7 acres on Lacamas Lake. He had the first mansion in the area built there. His wife, Clara Duniway (1854–1886) of Portland, was daughter of Abigail Scott Duniway (1834–1915), a strong advocate of women's suffrage. She did not approve of Stearns, calling him a rowdy man with no culture nor money. So, when Mrs. Duniway was on a trip back East, the couple was quickly married. Clara contracted pneumonia after several years in Camas. She later died of tuberculosis, and her mother blamed Stearns for keeping her daughter in a damp house on the lake. He built a brick mausoleum at the Camas Cemetery and had his wife placed in a glass-covered crypt so visitors could view her. Her body was moved to Portland and her mother's ashes are interred with her. The mausoleum still stands, but it is locked up after being used as a tool shed for many years. After the first mill burned down in 1886, Stearns went in to real estate, but did not find success. He died in an old soldier's home in California after years of general debility and the loss of his voice. Before his work with Pittock, Stearns was a sharpshooter in the Union Army, and spent several months as a prisoner of war in 1865.

Hugh MacMaster

Born in Glasgow, Scotland, Hugh MacMaster (1867–1948) immigrated to Canada with his parents. His father, Aeneas MacMaster (1830–1888), came to LaCamas in 1883 and, seeing the prospects of the young mill town, built its first store, complete with living quarters on the second floor. Aeneas then sent for his wife, Elizabeth (d. 1907), and family. Hugh MacMaster set to work, clearing land for the new paper mill at a wage of 59¢ per day. He then worked at the mill once it began operations. After MacMaster's father passed, Hugh took over the goods and hardware store and remained at the helm until 1933. He was active in church and civic organizations, was mayor of Camas from 1915 to 1917, and was city clerk from 1935 until 1944.

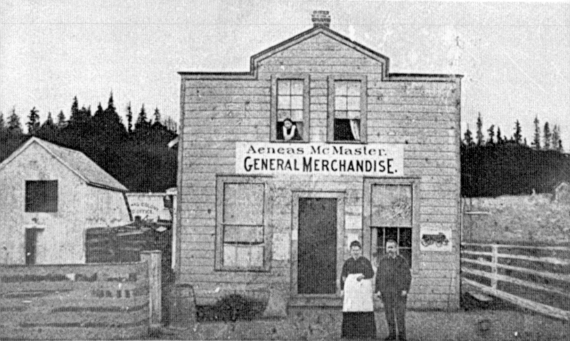

Here is where we started in 1883

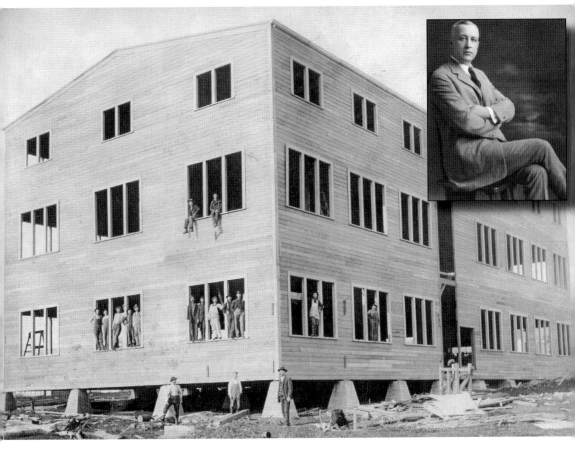

Clarence Bishop

The Bishop family began their long association with Washougal in 1912, when Clarence Bishop (1878–1969) purchased the struggling Union Woolen Mills to expand the family's Pendleton Woolen Mills business. In 1914, when World War I hit, the manufacturing focused on blankets for the troops. The mill was incorporated as the Washougal Woolen Mills in 1915. Bishop kept his eye on expanding the lines, so after the war they added flannels, cashmere, shawls and robes. A devastating fire gutted the main factory in 1924 but Bishop used insurance money to rebuild a new, expanded operation. Although the plant suffered through the depression as many did, Bishop found and hired good plant-superintendent management to navigate through the rough time. The Washougal mill continues to thrive under Bishop family ownership and leadership. Pictured is the first mill under construction in 1911, contracted locally by Thomas Jenny Sr. (1862–1932).

Wilmer Swank

A pioneer merchant, civic leader, and mortician, Wilmer Swank (1884–1952) arrived in Camas in 1902 and was a leader in establishing key facets of the young town. He opened a general merchandise store in 1905, which changed to selling furniture and hardware as W. Swank and Co., Inc. When the local undertaker passed away, Swank filled the role. After going to embalming school in Cincinnati, he created Swank Funeral Home, serving families between Vancouver and Goldendale. He moved both businesses to a new building in 1922. Built using stucco, it survived the fire of 1923 that destroyed much of downtown Camas. In 1932, Swanks Memorial Chapel was built. It remains standing in 2013 on the corner of Third Avenue and Cedar Street. Swank served as a two-term mayor of Camas and helped the city make great strides, constructing the first city hall and purchasing a water system. He went on to help form the Camas-Washougal Port District in 1935. At the time of his death, he was chairman of the port commission and active in the management of the store and funeral home. (Courtesy of the Swank family.)

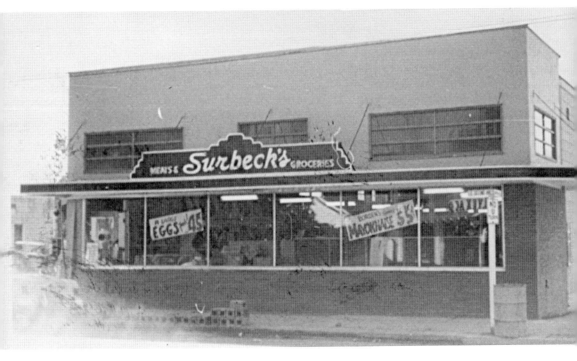

Arnold J. Surbeck

In the late 1950s, Surbeck's Market was the largest retail store in town and was considered a Washougal institution. Arnold J. Surbeck (1886–1967) and his wife, Katherine (1893–1993), served Washougal's grocery needs for more than 40 years. On Christmas Day 1911, Surbeck married Katherine Nagel, whose father was co-owner of Dibble & Nagel's General Store. In 1919, following World War I, Surbeck bought out Dibble, and the store became Nagel & Surbeck, selling general merchandise such as dry goods, clothing, plows, and food. The store became Surbeck's Market in 1936. After World War II, Surbeck's son Howard (1918–1959) led the change to a high-volume, low-price supermarket. In March 1958, the store moved from the original location of 35 years to a new store just to the south. During construction, the business did not miss a beat. When the new store was ready, employees came in on a Sunday after regular hours and moved the merchandise. On Monday morning, the store opened with everything in its place. After Surbeck's son's death from Hodgkin's disease in 1959, the family sold the business.

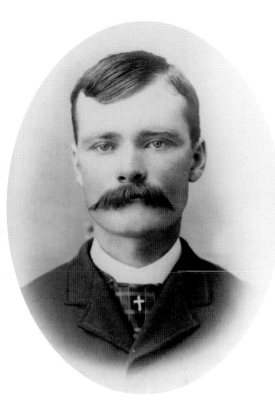 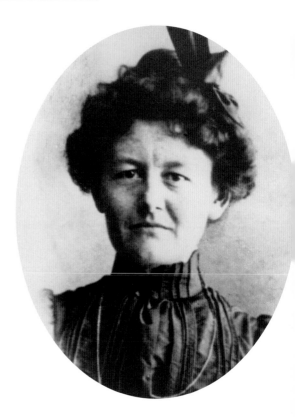

Charles E. and Ursula "Rose" Farrell

The first registered voter of Camas, Charlie Farrell (1869–1967) was an active and influential merchant, city councilman, and "everyone's friend." Arriving in the settlement of LaCamas at age 21, Farrell worked at the paper mill for 12 years before purchasing the Glenn Ranck General Store in 1903 and naming it C.E. Farrell General Merchandise. The store offered clothing, hardware, and groceries. Local farmers would sometimes barter their fresh produce for store items when their supply exceeded the demand in Portland. After 20 years in business, Farrell replaced the original old-frame building and leased the new structure to J.C. Penney Company. His wife, Ursula "Rose" Farrell (1871–1957), was one of Camas's first business women and operated a flourishing millinery business called the Fashionette. Rose's sister Anna Eddy (1883–1972) joined her as a bookkeeper and partner. The business moved back to the Farrells' building in 1934 or 1935 and began offering menswear and women's clothing and was named Farrell and Eddy. The Farrell and Eddy store served the community until May 1998. Charles Farrell was also a mayor of Camas and operated several successful business ventures. (Courtesy of the Farrell family.)

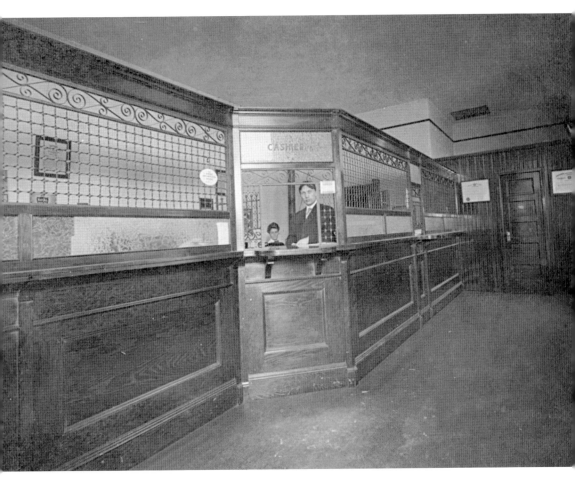

Oscar Franklin Johnson

O.F. Johnson (1880–1975) arrived at Camas in 1908 by riverboat with the intent to open the first bank in the newly incorporated city. Johnson's father-in-law, Emil Bauman, was a major stockholder, investing $5,000, with Johnson contributing $1,000. Johnson found the perfect location, at the corner of Fourth Avenue and Birch Street, and constructed the first brick building in downtown Camas. He opened the Camas State Bank on November 2, 1908, and worked as its first cashier. Later, he would be its president. According to the April 1909 issue of *Coast* magazine, the bank was "modern in all respects, supplied with the best fixtures and has one of the strongest, solid concrete, fireproof vaults in the state." The article went on to say that the bank officers were "practical, up-to-date men who have had wide banking and business experience." By 1915, the successful Camas State Bank was renamed First National Bank of Camas, and in 1919, it moved into the ground level of the new brick Urie Building. After 30 years in banking, Johnson retired in 1928. He left his business in good standing, as it was the only bank in Clark County to survive the crash of 1929 and continued, uninterrupted, serving his loyal customers.

John Alexander Cowan

Even with a financial interest in his father's store in LaCamas, John Cowan (1866–1934) worked many years in the lumber industry and at the Camas mill. From 1893 to 1897, he served as postmaster. But it was in 1899 that he opened Cowan Cigar Store. It was considered a real "man's place," selling tobacco and confectioneries as well as offering pool tables for use. Cowan's store had a lunch counter in front and a card table in the back room. His advertisements stated that he offered "The quickest lunch in town. Tobaccos, candy, pool." Cowan was elected the second mayor of Camas and served from 1909 to 1911.

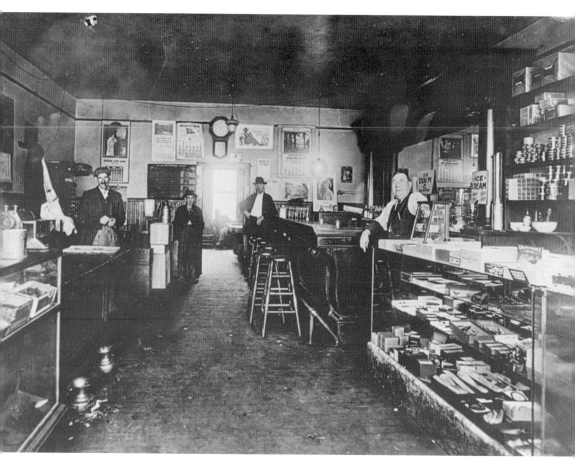

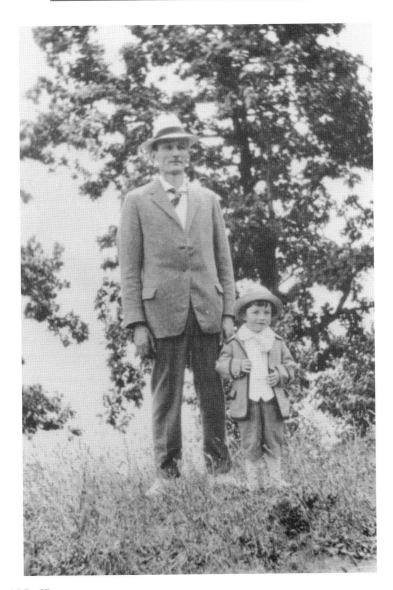

John Harold Roffler

John Roffler (1879–1924), the son of a pioneer family, was a carpenter and craftsman that left a legacy of beautiful Queen Anne–style homes throughout the Camas area. Roffler was just 22 years old when he was hired by Henry Pittock to help build a home for Pittock's son Fredrick and his new wife, Bertha Leadbetter, on the shore of Lacamas Lake. Known to locals as the Pittock-Leadbetter House, this project influenced Roffler's future work. In 1906, the newly married Roffler built a smaller version as his first home. This stately structure is located on the corner of Fifteenth and Everett Street across from Crown Park in Camas. The most famous and elegant of Roffler's work was the Charles E. Farrell House built for his sister Rose Roffler Farrell (1871–1957). Constructed in 1915, it sits on an entire Camas city block at the intersection of Northeast Fourth Avenue and Ione Street. Pictured with son Harold (1915–1988), Roffler suffered from attacks of melancholy and was admitted to the Mountain View sanitarium for treatment. Tragically he eluded guards and committed suicide by tying his shirt around a window bar in his room and hanging himself. Roffler was just 45 years old when he passed. His legacy will be the beautiful homes he created, many of which still stand today.

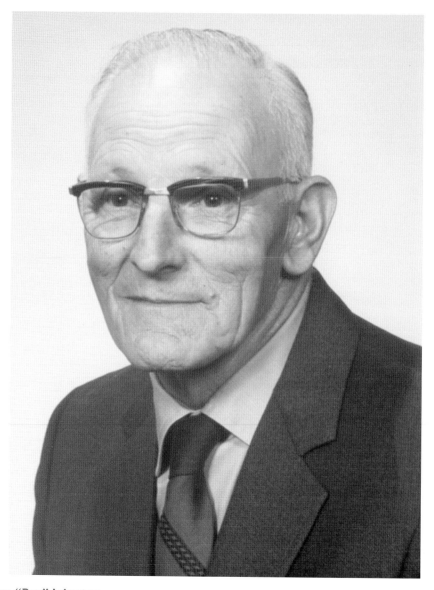

William "Roy" Johnston

Roy Johnston (1901–1974), referred to as a "dairyman ahead of his time," served on numerous agricultural boards throughout the county. He used the latest in milking technology and managed an award-winning herd of cows. He began selling milk to retail and wholesale customers in the 1930s, making deliveries in a Model T Ford truck. Johnston was forced out of the dairy business after World War II, when new controls came to the industry. While out of dairying, he and his wife, Viola (1907–2001), made use of the empty barn, hosting rowdy dances that would attract patrons from as far away as the Portland and Vancouver shipyards. Many longtime locals fondly recall the fun that was had at "Roy's Barn." Johnston returned to dairying in 1948. In 1958, the Johnstons were named Clark County Dairy Family of the Year. In the 1960s, the Johnstons welcomed classrooms of first graders from Washougal schools on yearly field trips. They opened the Johnston Drive-in Dairy in 1963, selling milk in glass bottles along with other quality dairy products. The dairy is still in family hands in 2013, owned and operated by Johnston's son Leroy (b. 1935) and grandson Lynn (b. 1959). (Courtesy of the Johnston family.)

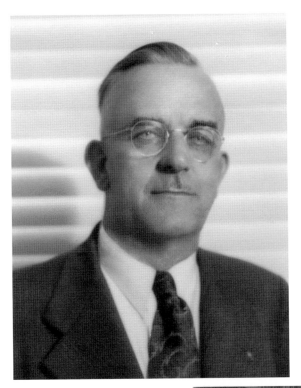

Edward H. Tidland

Edward Harrison Tidland (1889–1956) was an entrepreneur and inventor. An established blacksmith by 1909, Tidland worked for Crown Willamette Paper as a master mechanic and, later, as a consulting engineer for Pacific Coast Supply (Crown Zellerbach) until 1953. He founded Washougal River Gravel Company in 1928, which later became Rock Products, Inc. His Air Shaft invention, a roll-holding paper mill component, fostered Tidland Machine Company, which he founded with his son Bob (1923–2013) in 1951. He was president until 1956. Tidland was cofounder of Camas First Baptist Church and was a Camas city councilman. (Courtesy of Roberta Tidland.)

James David Zellerbach

James D. Zellerbach (1892–1963) was a president of the Crown Zellerbach Paper Corporation while the Camas mill was under its ownership. Created by his grandfather in San Francisco, the Zellerbach Company grew under James's leadership into an immense business enterprise. After serving as an administrator for the Marshall Plan, Zellerbach went on to become the US ambassador to Italy. He was honored by the Camas School District with the dedication of the James David Zellberbach School in 1966. The facility is now the Zellberbach Administration Center and is home to the Camas School District offices.

W.C. "Carl" Mansfield

Living a full life of colorful careers, Carl Mansfield (1889–1980) was well known and highly respected for his business expertise. He and his wife, Pearl (1894–1972), owned and operated Camas Mercantile, a dry-goods store in downtown Camas, until his retirement in 1946. His prowess as a mathematician was legendary. Mansfield was one of the founders of Clarke County Savings and Loan, the precursor to Riverview Community Bank. He served on its board of directors for 46 years. Mansfield farmed 150 acres near Lacamas Lake and owned many rental properties. He was also a moneylender, assisting locals in start-up businesses. Mansfield was a cofounder of Orchard Hills Golf and Country Club and was a champion golfer. (Courtesy of Gail Weakley Gregg.)

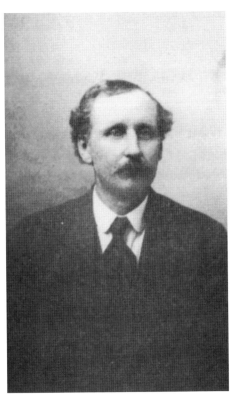

John Ginder

The first newspaper in Camas was the *LaCamas News*, published by John Ginder (1857–1937) in 1887. The son of Vancouver pioneers, Ginder began working on area newspapers at the young age of 16 as a "printer's devil." Through the years, he became an expert typesetter. He sold the *LaCamas News* just a year after starting it. He bought the *White Salmon Enterprise* in 1903 and then became owner and editor of the *Skamania County Pioneer* in 1909. Ginder moved to Camas after retiring in 1922 from his long career in the newspaper business. (Courtesy of Rose Marie Harshman.)

Tom Woolson

The type and caliber of entertainment in early Camas took a huge leap forward when Tom Woolson (1880–1930) opened the Camas Opera House. Woolson built the structure in 1908 and operated the business until 1926. He opened to a full house, presenting the comedy-drama *Hearts of Gold*. Woolson's facility hosted many silent movies, school functions, basketball games, operettas, and graduation ceremonies, even the very first Camas Firemen's Ball in 1924.

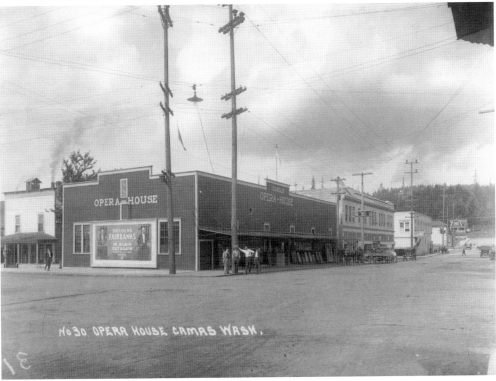

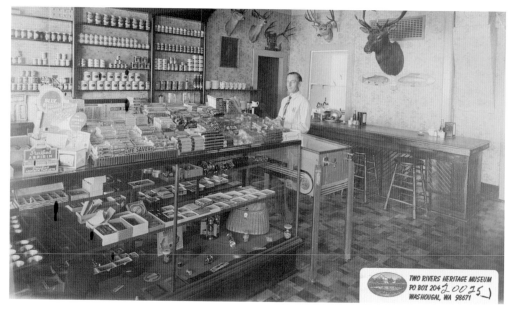

TWO RIVERS HERITAGE MUSEUM
PO BOX 204
WASHOUGAL, WA 98671

Fritz R. Braun Jr.

An avid fisherman, successful businessman, civic leader, and friend to many, Fritz Braun Jr. (1882–1959) provided considerable service to the town of Washougal. Braun ran the family's Smoke Shop after his father's death in 1917. He converted half of the establishment into an ice-cream parlor and half into a pool hall and cigar store. Braun was involved in many civic affairs, such as the creation of a city park, and he was president of the Washougal Bank from the time of its organization. The first white male born in the settlement of Washougal, Braun died tragically. Fishing on the Columbia River near Cooks, Washington, on July 4, he and his brother-in-law Emil Jarmann (1900–1981) were returning to their cars and crossing the railroad tracks when a train, unheard by the men, barreled out of the tunnel. Jarmann was able to fall back to avoid the train, but Braun, just a step ahead of him, was killed instantly. Braun is pictured below with his wife of 40 years, Judith (1892–1981). (Bottom, courtesy of the John Knapp family.)

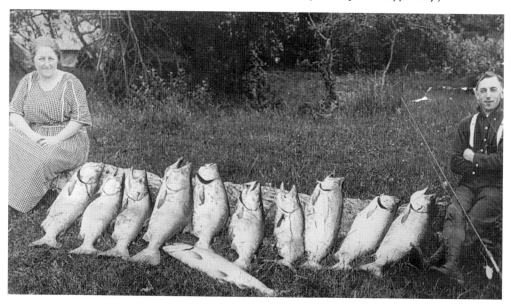

Selden "Pat" Mason
The Wagon Wheel Park, owned by Pat Mason (1907–2001) and his wife, Alta (1917–2013), opened its doors in 1948. Located on Third Street along the banks of the Washougal River, it was nearly lost to flooding later that year during the Memorial Day Flood. The Wheel quickly became the area's social hotspot for skaters and dancers, and it remained so for nearly a decade. Singing great Willie Nelson and Mason met while working as DJs at KVAN radio in 1953. The two became lifelong friends, and Nelson could be heard playing with the Wheel's house band on Saturday nights. Mason was a promoter with Nashville's Grand Ole Opry road show and brought many of those acts to entertain locally. Mason also started the popular singing group Paul Revere and the Raiders and was their original booking agent. (Courtesy of Willard Carroll.)

Robert N. Gaines

Bob Gaines (1882–1978) owned one of Camas's first service stations, at Third Avenue and Adams Street. Gaines started with a variety of jobs at the Camas mill, delivered mail on horseback, and worked at Cowan's Cigar Store. He then established and quickly sold for a profit a card room and the Palace of Sweets in downtown Camas. Gaines tried his luck at starting a pool hall in Portland. He lost heavily, then returned to Camas in 1924 to open a Texaco station. He started Van's Fuel Oil Service in 1946 and, soon after, retired.

Arthur "Art" Gaiani

Thanks to building more than 50 homes "the old-fashioned way," many of the Camas-area custom residences built by Art Gaiani (1916–2012) still proudly stand. Gaiani's method was to do the whole project by himself, from the foundation to the cabinets, thus ensuring the highest quality. A 1936 Camas High School graduate, Gaiani (pictured at the left) worked in construction after returning from World War II in 1945 until his retirement in 1975. His father, Charlie (1876–1959; pictured holding Art Jr., b. 1956), built the original Lake Store in the 1930s. (Courtesy of Marquita Gaiani Call.)

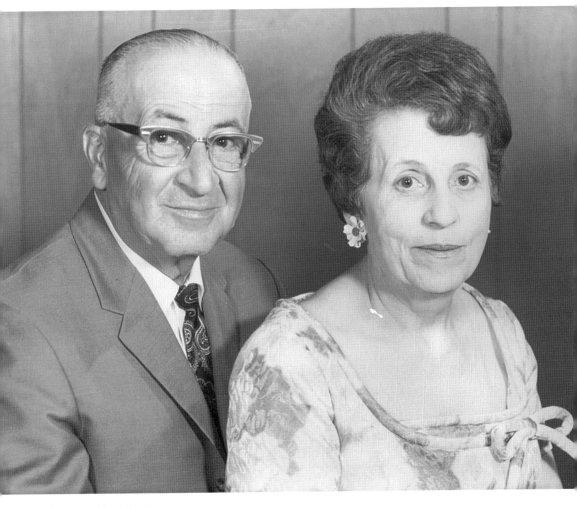

Mickey and Hazel Schwary

Known by many as an intelligent businessman who was willing to try new things, Mickey Schwary (1898–1984) had a pioneering idea for the One-Stop Shopping Center between Camas and Washougal. It became a great success. The center was patterned after similar modern shopping centers he had seen in California. Built in 1949, the center at its heyday comprised of 14 stores, including Save-on Drugs, an appliance store, a dry cleaners, Melvin's Men's Shop, Western Auto, a shoe store, and a restaurant. Portland businessman Fred Meyer was said to have visited the center, which helped motivate him toward the concept of "one-stop shopping" stores. Years before One-Stop, Schwary and his wife, Hazel Rehal (1905–1994), owned and sold a number of grocery stores in the area. Hazel was a keen businesswoman who, as a child, learned from her widowed mother, who was left to run the family grocery. Hazel had a major role in running their businesses and keeping the books. The Schwarys took the helm of the Camas Public Market in 1927. When the Depression hit, customers would often pay with whatever produce they grew, or worked around the store. As a Camas-Washougal port commissioner from 1961 to 1967, Mickey Schwary was instrumental in the purchase of property that is now a part of the port's industrial park. Although some voters resisted that decision, it created jobs and commerce that have been of great benefit to the area. (Courtesy of Joanne Fletcher.)

Glenn Farrell

The driving force behind today's lush park appearance of downtown Camas was longtime resident, avid gardener, and admired businessman Glenn Farrell (1907–1989). Born above the downtown general store owned by his parents, Charlie and Rose, and delivered by pioneer doctor Louisa Wright, Farrell was a true son of Camas. A 1926 graduate of Camas High School, he graduated with honors in 1930 from the University of Washington and worked in Portland before marrying his high school sweetheart, Helen Drewfs (1909–1996), in 1934. They returned to Camas and operated the family's Farrell and Eddy Department Store, while he quietly provided vision and service to the community. Among his contributions was helping to gain the governor's support for a Camas National Guard unit during World War II and serving in the local civilian patrol. Farrell was a member of the Riverview Community Bank Board of Directors (1970–1980), serving as president and as chairman of the board. (Courtesy of the Farrell family.)

George Francis Henriksen

A local pharmacist and active community volunteer for many years, George Henriksen (1914–2001) was well known and well respected by many in the area. In 1940, he and Ray Bachelder (1890–1999) began Camas Economy Drug in downtown Camas. Then, in 1948, he moved to the newly built One-Stop Shopping Center and started Save-on Drug. Henriksen's community involvement began as chamber of commerce president in the mid-1940s. His strong belief and support of education was demonstrated by his leadership on campaign committees for school levies, most notably, the levy to build the new Camas High School in the 1950s. Henriksen was known to many as "Mr. Republican," holding many posts within the local party. He retired in 1977, selling the business to his daughter Nan. Henriksen was described as "a fast talker, hard worker, live wire, civic enterpriser, dedicated volunteer and family man." (Courtesy of Nan Henriksen.)

Norm Danielson

After his successful career building a grocery business, Norm Danielson (b. 1915) spends his retirement building his community through financial contributions. Danielson began with the purchase of a hardware store in downtown Washougal in 1938, and went on to open a chain of Danielson Thriftway grocery stores. A risk that paid off was purchasing land on 164th Avenue in east Vancouver before the I-205 Bridge or any significant development existed in this now-thriving area. Extremely grateful to his local customers, Danielson has made significant contributions to local schools and children's programs. He also contributed $50,000 to the Columbia Land Trust for the acquisition of a critical section of land for the Cape Horn Trail. He also gives regularly to health-related associations. Soccer fields in Washougal, made possible in part by his gift to the school district, bear his name. (Courtesy of Norm Danielson.)

Paul and Barbara Runyan

Believing that, sometimes, it takes a businessperson to help a government agency run more efficiently, Paul Runyan (b. 1934) of Runyan's Jewelers in Camas used his business know-how successfully during his 14 years as a commissioner for the Clark County Public Utilities District (now Clark Public Utilities). Runyan, a Camas High School graduate, was also a Camas volunteer firefighter and emergency medical technician for 25 years. Runyan and his wife, Barbara (b. 1934), were third-generation owners of Runyan's Jewelers. Runyan's grandfather Leonard began the business in Vancouver in 1917. In 1946, Paul's father, Emerson (1911–2007), opened the store in Camas. Paul and Barbara later took over the business, and, upon their retirement in 1997, their daughter Debbie (b. 1960) took it over. Runyan's Jewelers, with its long tradition of excellent customer service, has become a fixture in downtown Camas. Emerson is pictured below with his wife, Lola (1912–2006). (Both, courtesy of the Runyan family.)

Hugh Adelbert Knapp
It was a source of pride for Hugh Knapp (1921–2007) that his Camas law office was located just blocks from his grandmother's home, where he was born. A 1939 Camas High School graduate, Knapp was a highly esteemed attorney for the Port of Camas-Washougal for more than 30 years of his 45-year legal career. One of his significant accomplishments was providing legal counsel as the port invested in property that is now the industrial park. At the time of his retirement, Knapp received recognition from the Washington Public Port Association as one of the top port attorneys in the state. During his career, he had been before the State of Washington Supreme Court about 10 times. In 1979, he went to Washington, DC, and was admitted before the US Supreme Court. Knapp's son Roger joined the firm in 1977 and continues to practice in 2013. (Courtesy of Roger Knapp.)

Carl Gehman

Carl Gehman (1917–2006) opened his sporting goods center in downtown Camas in 1957. It was a favorite spot among sportsmen. Gehman, an avid hunter and fisherman, was an expert on the area's rivers, lakes, and wilderness. His customers counted on him for tips on where to find the best hunting and fishing at any season of the year. Gehman was a victim in a tragic series of crimes on November 17, 1959. A man seeming to buy a gun and ammunition loaded that gun, robbed him, and locked Gehman in the store basement. The robber, John R. Broderson, had just murdered Harold O. Oster (1908–1959) of Camas, a car salesman for Westlie Ford. Broderson stole the car that he had pretended to take for a test drive. But the killer was not finished. He told Gehman that he planned to use the gun to murder his wife in Oregon. Gehman escaped in time to alert authorities to the plot, and a roadblock was set up at Heppner, Oregon. The assailant was captured, but not before taking two people hostage and injuring an Oregon state policeman during the arrest. Gehman's escape and quick action undoubtedly saved lives and led to the capture of Broderson. While running the sporting goods store, Gehman and partner Vi Wagner, his sister-in-law, owned the Imperial Cleaners. For a time, the two businesses were located across from each other, and family members joked that Gehman "worked both sides of the street." (Courtesy of the Gehman family.)

George J. Schmid

A lifelong resident of Washougal, George Schmid (1929–1999) had a passion for machinery. He founded George Schmid Excavating in 1957 with his wife, Emma (b. 1932). In 1990, he started George Schmid & Sons, at which all seven of his children worked at one time. He oversaw many local projects that improved the community, including installation of underground utilities, the building of city, county, and state roads and the site development of Washougal's Evergreen Marketplace and Bi-Mart Shopping Center. On April 20, 1999, Schmid was recognized with a state senate resolution recognizing his "substantial contribution to the development of the Camas/Washougal community, for his charity toward the community, and in general, for his great sense of duty to the community in which he was able to succeed from humble beginnings." Soccer fields along Evergreen Boulevard carry his name, thanks to a donation of construction labor by George Schmid & Sons in 2001. (Courtesy of Carolyn Simms.)

CHAPTER FOUR

Educators and Physicians

The influence and contribution of doctors and educators in small communities is often significant. That was definitely true in Camas and Washougal. Pioneering doctors, such as Louisa Wright and Donald Urie, served tirelessly, making house calls, summoned for any given ailment and at all hours of the night and day. Later, during the Depression and into more modern times, if patients of doctors such as Horace Eldridge or Karl Stefan were not able to afford their fee, payment would be made in farm produce or labor services. Many of the doctors of Camas and Washougal would see a family over a generation, treating parents, children, and then grandchildren. They were beloved for their genuine concern about the people they cared for.

Teachers, coaches, and school administrators shape not only students but communities as well. Teacher and administrator Nora Self, with her no-nonsense disposition, gained respect by giving respect. Eldon Phillips, who led the Washougal Drum and Bugle Corps, gave students and the community a source of pride during the difficult years of the Depression. Teachers Helen Baller and Dorothy Fox were honored for their many years of dedication to students and education with schools bearing their names. The tireless Donna Cooper continues her work in the counseling department at Camas High School after more than 60 years within the district. Educators inspire their students to grow and learn, leaving a lasting impact on the lives they touch. Strong communities start with strong schools. Camas and Washougal have benefited from the education provided by so many dedicated individuals, many of whom are featured in this chapter.

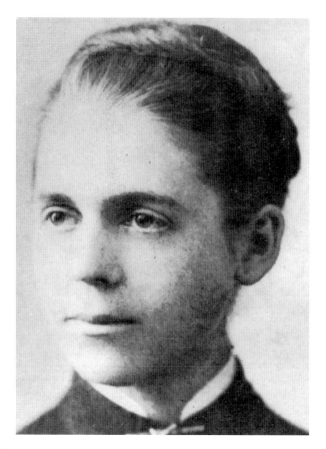

Dr. Louisa Wright

Louisa "Lutie" Wright (1862–1913) was one of the first doctors, and the first female doctor, in the Camas-Washougal area. The daughter of Camas pioneer Lewis Van Vleet, Wright was determined to become a doctor from a young age. She worked as a teacher at a variety of area schools, earning $25 a month, much of which she saved for medical school. Wright attended the University of Oregon for her undergraduate studies, and she received her medical degree in 1885 from the University of Michigan in Ann Arbor at just 23 years old. In 1887, she returned to the Fern Prairie area of Camas and married the local druggist, William Spicer. They had three children and later divorced. She helped patients through sicknesses such as flu, measles, scarlet fever, and typhoid, and she delivered many local babies. Wright cared for patients from Yacolt to Mount Norway, initially traveling sidesaddle on horseback before getting a horse-drawn buggy. She was also known to care for local Indians. Traveling to see patients was often difficult, such as the time she was summoned by a man whose wife was severely ailing. On the journey to the patient's home, a large tree had been blown down, blocking the roadway. Quickly, Wright and the man led the horse under the tree, disassembled the wheels from the buggy, and reassembled them on the other side to continue the drive. In 1901, she married the Camas liveryman James Wright, a widower and father of five. Tragically, her life was cut short in 1913 when a horse hitched to her buggy startled at her white apron, reared up, and struck her under her chin, breaking her neck. Her funeral was held at her home and office at Parker's Landing and was attended by many of her former patients, including Indians who made their way via canoe on the Columbia River. Dr. Wright is buried next to her father, Lewis Van Vleet, in the Fern Prairie Cemetery.

Helen Baller

Helen Baller (1890–1976) began teaching in 1924 at Central School and later was the primary supervisor for Forest Home, Oak Park, and Central Schools. Said to be a brilliant woman, Baller was honored with having Camas's Helen Baller Elementary School named for her. This was a tribute to her dedicated, progressive, and effective teaching and supervisory methods. Additionally, she was known for her pleasant personality and love of children. Active in the community for 25 years, she was a member of both the Soroptimists and the Business and Professional Woman's Club.

Dr. Donald C. Urie

In honor of the passing of Don Urie (1879–1937), local businesses closed for a half-hour and displayed sprays of flowers on their doors. Urie came to Camas in 1909 and took over the practice of Dr. Lousia Wright (1862–1913). An avid outdoorsman, he was well respected for his service in the early days of medicine in rural Camas. (Courtesy of the Swank family.)

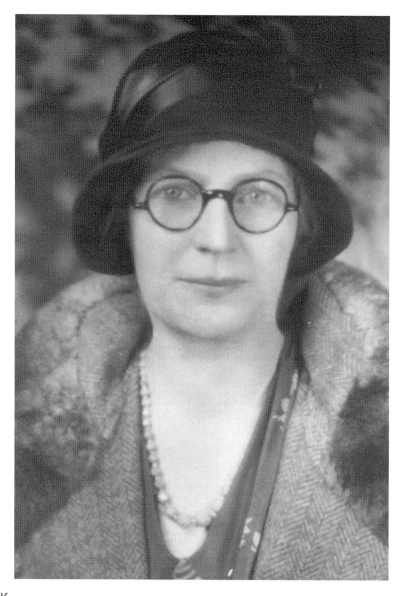

Nora Self

There is no question that Nora Self (1888–1958) left an indelible mark on the community. She had a 33-year career in Washougal and Camas schools as a teacher and administrator and was a charter member of many service clubs and organizations, especially those promoting the interests of women. Referred to as "The woman everyone loved," Self was respected for her practical, fair, and direct manner. An incident that demonstrates her calm approach to issues happened in 1946, when two high school buddies, Curtis Hughey and Wilton Kahler, decided to take dates to Portland after the high school operetta. They ended up with three girls, so they quickly recruited a third boy, Charles. After a fun night out, they snuck home in the predawn hours, and all seemed fine. Monday morning, however, Hughey and Kahler were called to the principal's office. Self questioned the boys and was satisfied that no dastardly deed had been done. She explained that Charles's mother had contacted her on Sunday to reprimand the students who "corrupted" her boy. Self gave the young men a knowing smile and excused them with the parting words, "I suggest you two be a little more prudent in your selection of friends."

Dr. Arthur K. Harris

Camas High School football players for more than four decades have memories of a serious man in a hat and raincoat standing along the sidelines of every home game. That man was Doc Harris (1894–1990). For his service as the volunteer team physician and his years of providing free sports physicals to Camas athletes, the newly built football stadium was dedicated as the Dr. Arthur K. Harris Stadium in 1970. Harris joined the practice of Dr. Donald C. Urie (1879–1937) in Camas in 1930, during the Great Depression. His support of high school football began at that time. Recognizing the need for school sports, he and other local businessmen came together to raise funds for football gear. Harris was committed to the well-being of the entire community, supervising routine blood drives during World War II and helping form the community chest. He continued his work with blood drives for 30 years. Harris had his practice in the days of house calls, when most babies were born at home. In one instance, a husband drove Harris to his wife, who was in labor. They parked the car on a side road and continued up a trail and across a foot bridge to the cabin. A neighbor had been waiting with the woman, but both the neighbor and the husband left abruptly when Harris arrived, not caring to be present for the birth. With no fire in the stove or water in the kettle, Harris was on his own. The baby was delivered and dressed by the time the father returned. In the early days of his practice. Harris was accustomed to getting meat and produce as payment for his services. He never did worry much about his fees. When told that, if he charged for all of his services, he would be a wealthy man, Harris scowled and said, "What's money?"

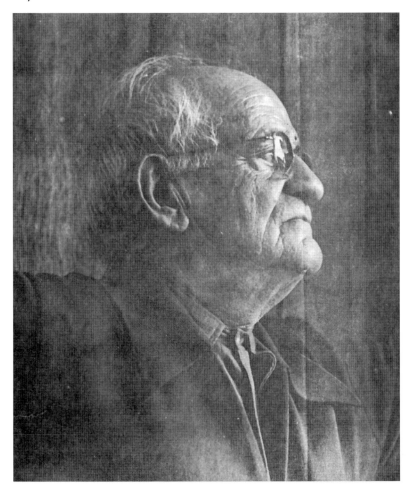

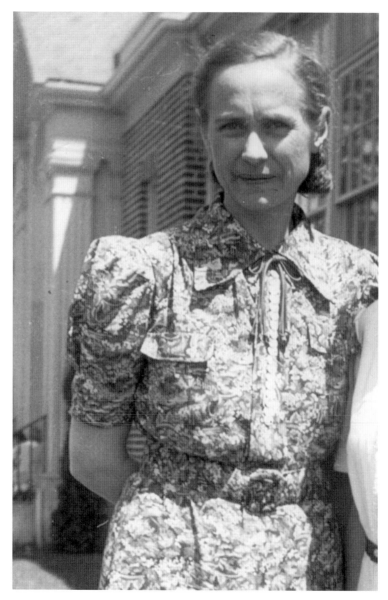

Gudrun Jemtegaard

Gudrun Jemtegaard (1903–1990) was honored for her 42-year teaching career in Mount Pleasant and Washougal schools, as the Washougal School District opened a middle school in her name in 1981. Jemtegaard, a Washougal High School graduate, was an immigrant who said her own struggle to learn English made her a better teacher. She graduated from Ellensburg Normal Teachers College and began teaching in 1924. Paid just $100 a month for her work with all eight primary grades in a one-room schoolhouse, Jemtegaard also earned an additional $10 per month to work as a janitor there. When the Depression hit, her first-grade class grew to 65 students, due to families arriving from the Midwest fleeing the Dust Bowl. At one point in the 1930s, her salary was just $65 per month. During World War II, Jemtegaard worked two jobs, joining other women to work in the Camas mill as the men were called away to serve. Jemtegaard was remembered for her love of students and her belief that a teacher must find one thing that the pupil is interested in and build on that.

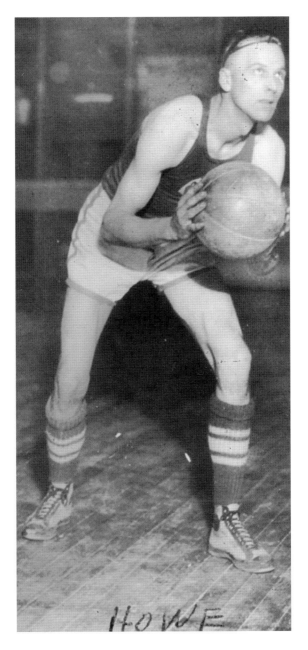

Fred P. Howe
After a brief three years of teaching and coaching in Camas in the mid-1920s, Fred Howe (1901–1952) returned in 1934, this time to stay. A well-respected teacher, coach, and administrator, Howe most enjoyed working with junior high students. He was passionate about creating programs and activities for young people to build self-esteem and help them be successful in school and beyond. As Camas Junior High principal, Howe worked with teachers and administers to develop a broad range of activities for students. He coached a variety of sports but had a talent for basketball, playing on a Camas community team that won the 1923–1924 Clark County championship and, later, received a scholarship to play for Oregon State College. The gymnasium at Liberty Middle School in Camas is honored with his name. (Courtesy of Virginia Warren.)

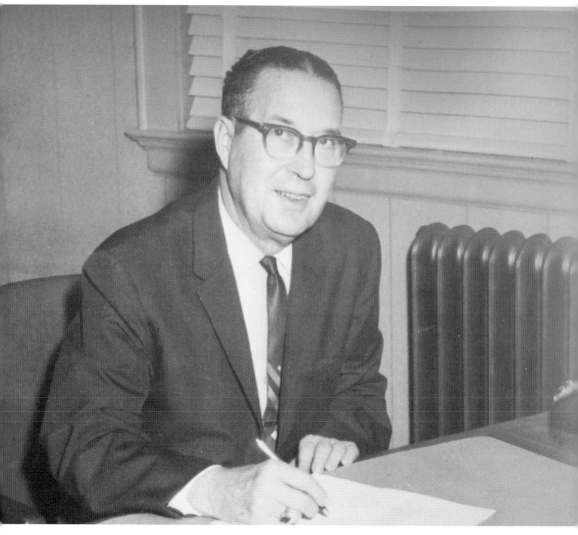

John Fishback Sr.

A Washougal superintendent for 20 years, John Fishback (1910–1966) was not a "bookish" person; he joked that no one would probably name a school after him. He was right. It is not a school, but the stadium at Washougal High School (WHS) that proudly bears his name. Fishback was a young superintendent when he came to Washougal in 1946. He married Ellen Elizabeth Bennett (1909–1999) in 1934. She taught fourth grade in Washougal for 20 years. One of the first projects Fishback undertook was to destroy the dangerous two-story wooden middle school and build Gause School in its place. Another large project was the construction of Washougal High School in 1958. All levies held during his tenure passed, with the exception of one kindergarten levy. He was a very personable man and took great interest in the teachers, hand-delivering their paychecks and helping them to find places to live once he recruited them. Fishback was on a recruiting trip with good friend Al Hoffman, Stevenson District superintendent, and stopped to have lunch at Washington State University with his daughter Jeffra before heading to Whitman College. The next morning, when Hoffman tried to wake Fishback, it was discovered that he had passed. The funeral was held in the WHS gymnasium, of which he proudly oversaw construction.

Dr. Emil W. Brooking

The day after his medical internship ended, Emil Brooking (1915–2006) was drafted into service in World War II. His military career ended in 1946, and he joined the medical practice of Dr. Lewis Carpenter in Camas. For more than 42 years, he served local families in a profession he was well suited for. His patients were more than just that; they were his friends.

Dr. Horace L. Eldridge

Dr. H.L Eldridge (1904–1965) had great concern for the health of his patients as well as his community. In addition to leadership in a number of state medical associations, Eldridge was president of the Bank of Washougal and president of its board of directors. He was a strong advocate for Washougal and helped support the city's expansion and development. Eldridge was also a farmer and operated the Washougal Guernsey Farm. A city park bearing his name is located on former farm land at 2211 Forty-ninth Street.

Dorothy Marie Albright Fox
With a teaching career spanning nearly 40 years, Dorothy Fox (1921–1982) was a much-loved educator in Camas with a passion to help children develop to their full potential. In 1982, the newly built elementary school on Prune Hill was dedicated in her name. Due to failing health, she was not able to attend the tribute given to her for her long and dedicated service. Sadly, she passed later that same year.

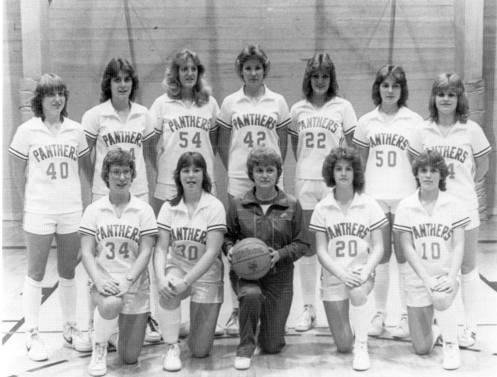

Joyce D. Cox
As the first woman's coach at Washougal High School (WHS), Joyce Cox (1934–2012) helped implement the Title IX law in Washington State. During her 31-year career in Washougal Schools, Cox taught at Jemtegaard Middle School (JMS) and introduced young women athletes to volleyball at JMS and track and basketball at the high school. She is pictured here with the 1982–1983 WHS team. Shown are, from left to right, (first row) Heidi Wolk, Shelli Long, Joyce Cox, Kim Rink, and Michelle Peterson; (second row) Kim Stender, Cheri Lamb, Polly Loggins, Katrina Broderick, Pam Stone, Dana Weller, and Brenda Haag. (Courtesy of the Cox family.)

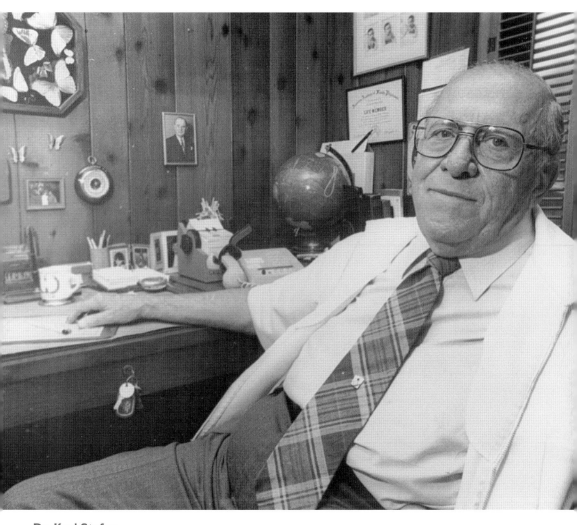

Dr. Karl Stefan

At his retirement in 1987, Karl Stefan (1910–1992) still made house calls and did not require patients to make appointments. Stefan joined Dr. Horace Eldridge (1904–1965) in a practice in Washougal during the Depression, when it was difficult for some patients to pay for medical services with money. One day, he received a payment in the way of four-dozen dead chickens on his porch; he spent the next day cleaning them. He was drawn to medicine to help people, and he believed the best approach to treatment was holistic, treating the whole person. Stefan made deep connections with his patients and did not need to refer to a file to know their name and history.

Joe Brown

The Washougal High School basketball court proudly carries the name of Joe Brown Gymnasium. This recognition honors Brown's four decades of successful basketball coaching and the hundreds of athletes he influenced. In his 14 years as head coach, Brown (1934–1990) had 13 winning seasons, reached the postseason for 12 years, and led his team to five straight Trico League championships and state tournament appearances. He possessed a love of teaching, coaching, and, above all, learning. The son of a research physicist, Brown grew up in Hawaii. He had an easygoing manner, which endeared him to students, family, and the community. (Courtesy of Jane Dally.)

Donna Cooper

For more than six decades, Donna Cooper (b. 1930) has been a guiding light to Camas students when things are rough. Starting in the district as a junior high school physical education and health teacher in 1951, Cooper found herself in counseling situations and had a knack for helping students. When a high school counselor job was offered to her in 1972, she was happy to get additional training and take on that role that she continues in 2013. It is often years after a student has left the school that Cooper will hear that her support and guidance made a difference in their lives. After all these years, she says that young people are the same as always. It is society that has changed. At a very young 83 years of age, Cooper feels blessed to have been doing this work as long as she has. (Courtesy of Donna Cooper.)

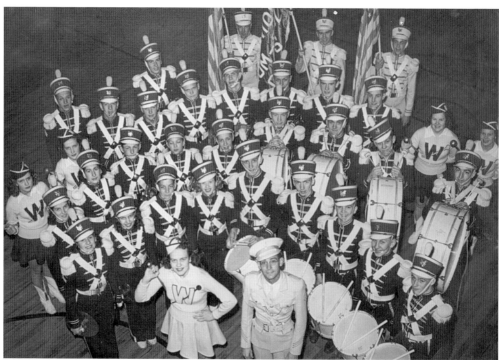

Eldon S. Phillips

The Washougal Drum and Bugle Corps struck a chord with the entire community under the leadership of Eldon Phillips (1912–1994). Getting its start in 1935 during the difficult days of the Depression, the corps gave students an activity to be proud of. While money was scarce, mothers sewed uniforms and fathers worked to raise needed funds. Phillips took the group to numerous competitions and parades, often coming back with top honors, including first place at the Portland Rose Festival. They also earned three consecutive state junior championships in the American Legion Competition. Phillips had a 37-year career in the Washougal School District, 22 of those years as principal at several schools. He was a charter member of the Washougal Lions Club, and the driving force behind the Washougal Pow Wow Rodeos in the early 1950s. (Both, courtesy of Irma Hornbeck.)

Gordon Washburn

It was a twist of fate and a lost Portland levy that brought Gordon Washburn (b. 1950) as a late hire to Washougal High School (WHS) in 1988. His first year leading the band, 20 students showed up, eight were drummers, none of which knew how to read music. Washburn also took over the middle school band, so he was able to begin to build the high school program. The hard work paid off, and by 1992, he started a jazz band for more advanced students. His sixth-grade bands had close to 30 new students each year. In 1995, Washburn took a group to an international competition in San Francisco. After three preliminary rounds, they reached the finals. By that time, Washburn knew his kids were spent. For their warm-up period, he told them to put down their instruments and go outside in the sun. For their performance, he told the students to keep playing, no matter what he did. As they performed the "Overture" to *The Marriage of Figaro*, he left the stage and came back at the end of the song to finish the 30-minute set. They played magnificently, won the competition, and received the only gold score. His band program just kept getting stronger and, after that year, did not score below third place in any concert band festival. The jazz band put up an unbelievable 21 straight places in competitions. In 1991, Washburn joined the WHS administrative team and assisted in the construction of the new high school. He was influential in hiring a Portland theater designer that saved the district hundreds of thousands of dollars in construction costs and resulted in a more useful electrical design. Washburn continues day-to-day management of the facility in 2013. There is rarely a show at "The Washburn" that he can not be found at the soundboard, backstage, or in the light booth. (Courtesy of Rene' Carroll.)

Martha Ford

At her death at age 105, Martha Ford (1888–1993) had the proud distinction of being the oldest living citizen of Washougal. Her German parents settled in Washougal in 1888. After high school, she lived in Germany with relatives to earn a diploma to teach German language. She returned to teach at Washougal High School in 1912, but World War I brought an abrupt end to her career. Everything German became taboo. Her family felt the discrimination and hatred shown to anyone of German descent. Although she admitted to having suffered, she did not grow bitter, but simply understood that "war is war and people get hurt." Ford went back to college to qualify for grade-school teaching and returned to Washougal. Known as a strict disciplinarian in the classroom, Ford was ultimately beloved and respected by the many Washougal residents she taught.

Dr. Keith "Doc" Price Keller

As a young boy in Portland, Oregon, Doc Keller (1923–1999) knew he wanted to be a veterinarian. While attending veterinarian school at Washington State College, Keller was drafted into World War II. After the war, he finished his education and began his practice in the Camas-Washougal area. He served his country for two more years during the Korean War, overseeing meat inspection for the troops overseas. Keller returned home to continue his 42-year career caring for animals, which included servicing injured animals found by City of Washougal workers and holding low-cost rabies clinics. He treated large and small animals, but his greatest enjoyment was cattle and horses. He was even called to Portland to treat the touring Budweiser Clydesdales. For many years, Keller drove to Stevenson, Washington, on Mondays and set up shop on the back porch of the Texaco distributor to save the owners of sick animals the long trip to Washougal. When he started his practice, Keller took care of large animals from Vancouver to White Salmon, including 30 dairies. At the time of his retirement in 1987, and with the change of economy, he was working with only two dairies. His practice evolved from 80 percent large animals and 20 percent small animals to 20 percent large and 80 percent small. During his retirement, Keller continued to care for the animals of friends and relatives. (Courtesy of Pat Emrich.)

Milt Dennison

With a keen belief in the importance to giving back to the community, Milt Dennison (b. 1947) has done so, to the lasting benefit of Camas. During his 11-year tenure as superintendent of Camas School District (1993–2004), he oversaw the construction of a new high school and led the district as it doubled in size. If that was not a big enough job, Dennison also founded the Camas-Washougal Rotary Club, was a strong supporter of the creation of the Jack, Will and Rob Center, helped steady a floundering community chest organization, and was a member and past president of the Camas-Washougal Chamber of Commerce. Known for his intelligence, wit, and humble nature, Dennison was one of the most popular superintendents in Camas history. (Courtesy of Milt Dennison.)

Joyce Garver

Joyce Garver's life was said to have been lived with exuberance! Garver (1928–2003) was a beloved music and art teacher at Camas High School (CHS) for nearly 40 years. The Garfield Performing Arts center was renamed for her in 2004. Garver may be best remembered for the long list of quality and entertaining musical productions she led. For many CHS graduates, being a part of one of those performances was the highlight of their high school years. Garver taught music full time for 10 years and later added art classes. She retired from music in 1982 to lighten her load and focus on her family. She retired from teaching in 1993. (Courtesy of Camas High School.)

Dr. Orlan Gessford

Appointed to the Washougal School Board in 1984, Orlan Gessford (b. 1936) went on to provide more than 25 years of service to the district. Gessford was a Camas dentist for 47 years and raised his family in Washougal. The son of a teacher, he considered a career in education, but did not find a fit, claiming he was probably a better dentist than he would have been a teacher. During his many years on the board, Gessford saw the district through some lean times, always pushing to maintain a budget to avoid overspending. One proud legacy Gessford leaves is his part in establishing the Senior Project program at the high school. Washougal was first in the state to make it a graduation requirement. Gessford has heard from many past students that the project challenged them and ultimately provided them with life skills and a higher degree of confidence as they left high school. (Courtesy of Washougal School District.)

CHAPTER FIVE

Celebrities and Memorable Locals

While most people featured in this book made their mark on the communities of Camas and Washougal, others grew up here and left their mark elsewhere. Drawing on inspiration from the area's beauty, a local mentor, or an educator, former residents have clearly achieved great things. They include notables such as Camas graduate Denis Hayes, now a leader in the American environmental movement, and Washougal graduate Wayne Havrelly, an award-winning television news reporter and anchor in Portland, Oregon.

Memorable as well are those who were taken from the world too soon. Their often tragic stories become a part of the communities they leave behind. For instance, the promising lives of Jackson, Will, and Rob Warren of Camas and Tim Edgley of Washougal are now sources of inspiration for area youth.

The character of a community is sometimes created from the characters that live there. Daredevil Seth Davidson kept the community buzzing with his death-defying adventures. Carl Buhman's corn whiskey, although widely but quietly admired, was created against the law. Marvin Jemtegaard took on many fights with bear and cougars—and won. This chapter spotlights those remarkable citizens who have shared their passion and inspiration with the world and in our hearts.

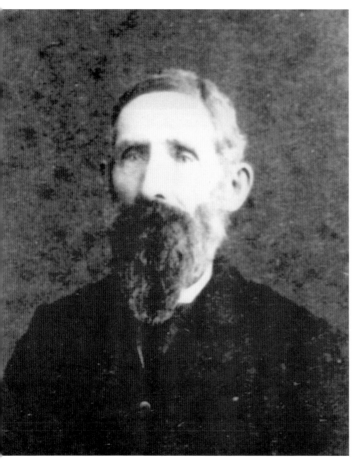

Henry Monroe Knapp
Henry Knapp (1829–1892) was one part farmer and one part politician. An early settler of LaCamas, he filed a Donation Land Claim in the Grass Valley area in 1853 and, in 1866, donated land for the first Grass Valley School. While establishing his farm on 320 fertile acres, Knapp also served in several county offices and was elected a member of the territorial legislature in 1859 and in 1866. Known as a powerful orator, Knapp spoke passionately against territorial suffrage and women's right to vote. In 1855–1856, he fought in the Indian Wars under Capt. William Kelly in the "Clark County Rangers," 2nd Regiment, Washington Volunteers. As a legislator, he was present for the signing of the Washington State Constitution in 1889 at the state capital in Olympia.

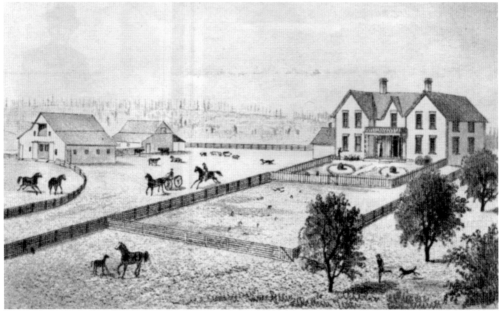

Harold "Hal" Zimmerman

As a longtime publisher, legislator, and citizen activist, Hal Zimmerman (1923–2011) earned the great honor of Citizen of the Century by the Camas-Washougal Chamber of Commerce in 2006. In 1957, Zimmerman and his wife, Julianne (1926–2010), purchased the *Camas-Washougal Post-Record* newspaper and operated it for 23 years. He had a keen interest in the community and was active in many local organizations. He championed numerous area projects like school levies, park improvements, and downtown revitalization. Zimmerman set his sights on the state house of representatives and was elected in 1966. In 1980, he was elected to the state senate, where he served until 1988. (Courtesy of the *Post-Record*.)

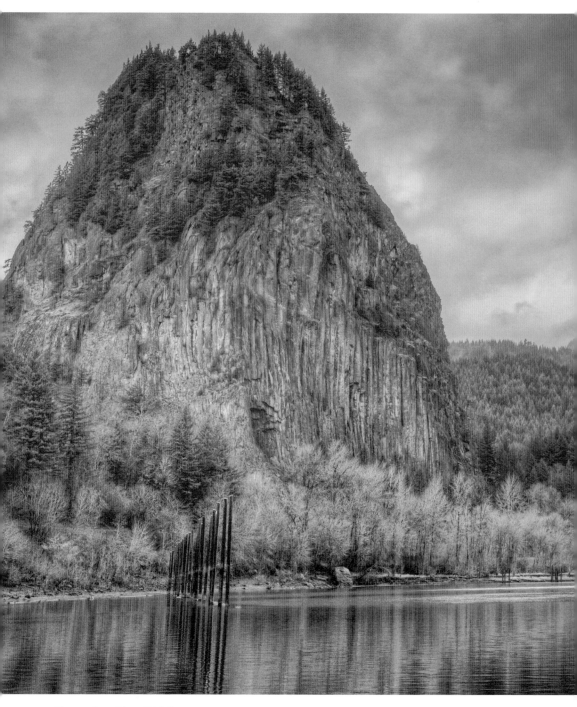

Henry Jonathan Biddle

The son of a prominent Eastern family, Henry Biddle (1862–1928) had a profound impact on the Columbia River Gorge. Well educated and well traveled, Biddle made his home on a 360-acre farm in Washougal along the Columbia River. He had a great interest in preserving Beacon Rock (pictured), Hamilton Mountain, and a nearby butte known as Biddle Butte, so he bought the property. He then

began creating trails and picnic areas. The crowning achievement was a trail to the top of Beacon Rock. Biddle's son Spencer and daughter, Rebecca Biddle Wood, donated Beacon Rock and Hamilton Mountain to the state in 1932 in memory of their father. They also bought Sand Island in the Columbia River just west of Camas to preserve it in its natural state. (Courtesy of Mitch Hammontree.)

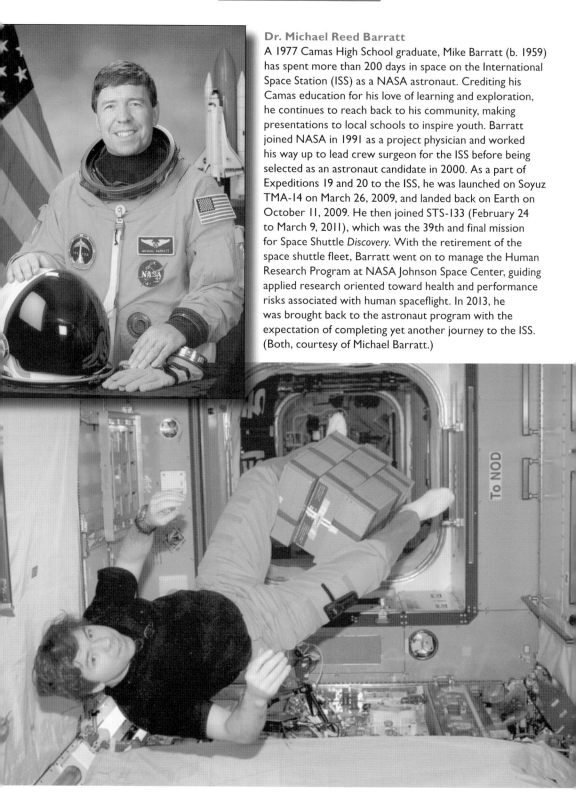

Dr. Michael Reed Barratt

A 1977 Camas High School graduate, Mike Barratt (b. 1959) has spent more than 200 days in space on the International Space Station (ISS) as a NASA astronaut. Crediting his Camas education for his love of learning and exploration, he continues to reach back to his community, making presentations to local schools to inspire youth. Barratt joined NASA in 1991 as a project physician and worked his way up to lead crew surgeon for the ISS before being selected as an astronaut candidate in 2000. As a part of Expeditions 19 and 20 to the ISS, he was launched on Soyuz TMA-14 on March 26, 2009, and landed back on Earth on October 11, 2009. He then joined STS-133 (February 24 to March 9, 2011), which was the 39th and final mission for Space Shuttle *Discovery*. With the retirement of the space shuttle fleet, Barratt went on to manage the Human Research Program at NASA Johnson Space Center, guiding applied research oriented toward health and performance risks associated with human spaceflight. In 2013, he was brought back to the astronaut program with the expectation of completing yet another journey to the ISS. (Both, courtesy of Michael Barratt.)

Raymond Hickey

Ray Hickey (1927–2010) would not accept that something could not be done. He began his work with Tidewater Barge Lines as a deckhand. Over his 40-year career with the company, he worked his way up to president. In 1983, the founding family of Tidewater sold the company to him. Upon his retirement, he turned his attention to philanthropy. Among his notable local gifts were funding for lifesaving equipment for the Camas Fire Department and donations to the Jack, Will and Rob Center in Camas and for the construction of the Ray Hickey Hospice House in Vancouver. In his book *Don't Tell Me it Can't Be Done*, Hickey describes the work ethic, values, and personal character it took to accomplish what he had with his life. (Courtesy of the Hickey family.)

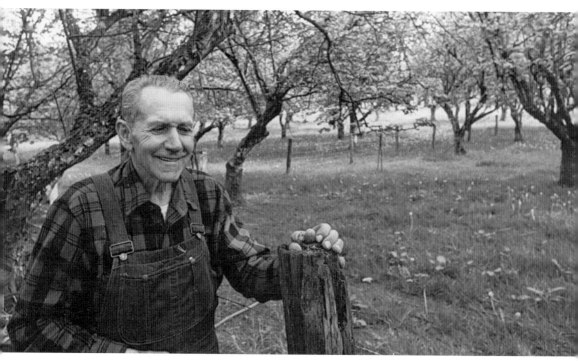

Marvin Jemtegaard

Cougars, black bears, and grizzlies were no match for master tracker and hunter Marvin Jemtegaard (1909–1988). As a boy, Jemtegaard would often spend all day hunting in the canyons around Mount Pleasant. His skill earned him a position as predatory hunter for the Washington Department of Game and sent him all over the state, hunting animals deemed dangerous to either residents or livestock. All told, Jemtegaard killed 63 cougars and 105 bears. Although never injured by a cougar, he had some close calls with bears. One bear knocked him into blackberry bushes and began mauling him before he could get a shot off from his pistol. Another got close enough to Jemtegaard to knock him unconscious. Luckily, the bear had been wounded and ran away instead of finishing him off. While hunting for a black bear that had killed a sheep on his Mount Pleasant farm, Jemtegaard was surprised when it came out of nowhere and attacked him. He was saved by his loyal hunting dog, which leaped at the bear and frightened it before too much injury could be inflicted. Jemtegaard was tenacious with his hunting. One cougar hunt went for 60 to 80 miles in the Wind River area of Skamania County and took three days and two nights, but it ended successfully. Renowned for his ability to track, Jemtegaard was also called out on Big Foot sightings to check for authenticity. (Courtesy of the Jemtegaard family.)

Orval Tandy

There was a parade in downtown Camas and a hero's welcome in 1953 when Air Force lieutenant Orval Tandy (1921–2004) returned home after two years as a prisoner of war in North Korea. Tandy's P-51 plane was shot down, and an eyewitness had seen his parachute open, but the search party did not find him. A 1939 Washougal graduate, he retired as a colonel after 30 years in the Air Force.

Barbara Heriford

An avid collector of dolls, antiques, and toys, Barbara Heriford (1930–1991) had dreams of opening her own store after retirement from the Pendleton Woolen Mill. She traveled throughout Oregon and Washington, attending doll shows and visiting antique shops to build her inventory. Unfortunately, Heriford passed away before realizing her dream. Much of her collection was donated to the Camas-Washougal Historical Society. They sold items not of museum quality to help care for her pieces that were kept for display and enjoyed by visitors.

Helen Johnson

Washougal native Helen "Sis" Johnson (1915–2009) was a part of aviation history, chosen to participate in the Women's Air Force Service Pilot program (WASP) in World War II. At a time when few women flew, Johnson received her civil aviation training at Washington State University in 1939 and reported for duty in the WASP program in 1943 at Avenger Field in Sweetwater, Texas. Flying Stearman PT-117 biplanes and North American AT-6 trainers, the women were put through rigorous training and constant evaluation. Unfortunately, due in part to weather conditions called "wind devils," Johnson was not able to pass a flight test and left the program after three months. Although personally devastated to leave, she was extremely proud to have been one of so few chosen to take part in the program. She continued to serve the war effort as a recreation club director for the Red Cross in England and Germany. (Courtesy of Grant Johnson.)

Charlie Hinds
Inducted into the National Wrestling Hall of Fame in 2013 with a Lifetime Service Award, Charlie Hinds (b. 1945) started the wrestling program at Camas High School in 1967. He was head wresting coach his entire 33-year career there. Hinds claims his success came from "luck along the way." Lucky, in that good athletes turned out, that he had great support from the school administration, that the media took an interest, that Al Antak was an amazing junior high coach, and that he had Roger Hamreus at his side as assistant coach for 25 years. Besides wrestling, Hinds coached girls' softball, freshman baseball, was head baseball coach three years, and was an assistant track coach as well as an assistant football coach for 28 years. A special accomplishment for Hinds was coaching his son in wrestling and his daughter in softball. He took both teams to state competitions. (Courtesy of Camas High School.)

Tim Edgley

A hard-working and well-liked track athlete at Washougal High School (WHS), Tim Edgley (1950–1969) had a bright future ahead of him. Edgley was a sprinter who, in his junior year at WHS, won the 220-yard race state championship. In addition, he won third place in the 100-yard dash and anchored the 880-yard relay team, which also earned third place. His efforts helped the panther team earn second place at state in 1968. During that season, Edgley also set a new district record in the 100-yard dash at 10 seconds, tied the district 220-yard record at 22.7 seconds, and was part of the team that set an 880-yard relay record of 132.1 seconds. Soon after he graduated in 1969, Edgley's family moved to Alaska, where he was tragically killed in an automobile accident. His name lives on at WHS in the Tim Edgley Award, presented each year to the Washougal track athlete that demonstrates a capacity for hard work and outstanding character. Edgley's body was returned for burial at the Washougal Cemetery next to his father, Marvin (1921–1997). (Both, courtesy of Washougal High School.)

Dr. Roy Laver Swank

A world-renowned medical researcher and clinician, Roy Swank (1909–2008) was a neurologist and professor emeritus at the Oregon Health & Sciences University (OHSU). He was inspired to pursue a career in medicine while growing up in early Camas. At the age of 13, he experienced patient care firsthand while driving around well-respected area physician Dr. Urie on his rounds. Swank graduated from Camas High School in 1926 and went on to earn his bachelor of science degree at the University of Washington and his medical degree and doctorate in anatomy from Northwestern University. With a distinguished career already in the making, Swank enlisted in the US Army in 1942 and went to Europe with the 5th General Hospital, Harvard University Unit. While there, he managed a 1,500-bed psychiatric hospital in Paris after its liberation. His treatment of soldiers suffering from shell shock and battle fatigue inspired some of the first papers published on these wartime syndromes. Later, he would work in Montreal, studying multiple sclerosis, which became his main research focus. He discovered a link between the disease and geographic location and diet. His research culminated in more than 170 scientific papers as well as the publication of several books on diet and multiple sclerosis, including *The Swank MS Diet Book*, which is still in print. In 1954, he was recruited by OHSU to be the first leader of the new division of neurology in the department of medicine. This was his chance to return to his beloved Northwest and direct his own research. In the late 1960s, Swank developed a transfusion filter to extend the viable life of blood and, subsequently, the Swank Cardiovascular Blood Filter, used during cardiovascular surgery. Demonstrating his entrepreneurial and pioneering spirit, manufacturing of these filters began in a clean room in Swank's Portland basement. The business grew to a Beaverton, Oregon, location and became Pioneer Filters. It was sold in 1977 to British Oxygen. His productive career resulted in extraordinary contributions to his patients, his field, OHSU, and the medical community nationally and internationally. Swank's body of work continues to have a vast ripple effect. (Courtesy of the Swank family.)

Denis Hayes

Credited as one of the major architects of the American environmental movement, Denis Hayes (b. 1944) is a 1962 Camas High School graduate. Memories of Camas in his youth, from the beauty of the Columbia Gorge to the awful sulfur smell coming from the smokestacks of the paper mill, inspired him toward his life's work. In 1970, Hayes left his graduate studies at Harvard Law School to become the national coordinator of the first Earth Day, an event initially proposed by Wisconsin senator Gaylord Nelson. More than 20 million people participated from coast to coast. The overwhelming success of the event led to the passage of a tidal wave of environmental legislation and drove Pres. Richard Nixon to create the Environmental Protection Agency. Over the last quarter-century, Hayes worked to spread Earth Day to more than 180 nations, of which he personally visited 150. Hayes has devoted his life to environmental values, serving as director of the federal Solar Energy Research Institute, a professor of engineering and human biology at Stanford University, and an attorney. He is currently the president and chief executive officer of the Bullitt Foundation in Seattle, where he recently completed the greenest commercial office building in the world. (Both, courtesy of Denis Hayes.)

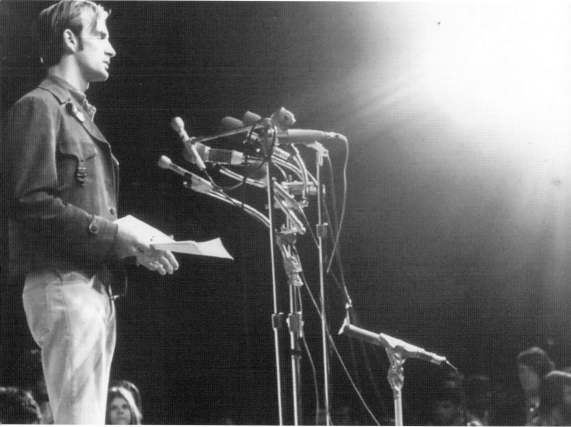

Richard Schwary
Schwary (b. 1929) was always interested in new business challenges. A 1948 Camas High School graduate, he received a master's degree in retailing from New York University. Despite job offers back East, Schwary returned to Camas to manage and renovate the family grocery store at the One-Stop Shopping Center; married his wife, Sandie, in 1955; and started a family. Numerous entities were created as a result of his entrepreneurial spirit and background in business, such as Western Auto Store, Washington State Bank (1970), construction of the Brass Lamp Apartments and Mobile Home Park, One-Stop Mini Storage Complex, and various investment properties. An interest in the radio business, where he had met his wife, prompted him to engage a group of like-minded investors and build the KPDX-49 (now Fox) tower. The FCC granted two radio station licenses. KKBR and KMUZ were the result of that business venture. Although holding a master's degree in business, Schwary's true passion is music. While in high school, he was a part of the band lead by Wayne Moffett that was the first out-of-state school group to perform at the Pasadena Rose Festival Parade with the lifting of gas rations after World War II. He started Dick Schwary's Big Band in 1949 and played lead trumpet for 50 years. This 18-piece band drew big crowds throughout the greater Portland–Vancouver area. He continues to play with his Portland Rose Dixieland Band. (Courtesy of Schwary family.)

Jackson, Will, and Rob Warren

The Jack, Will and Rob Center in Camas was created by Geri Pope Bidwell as a way for the spirit of her sons, the Warren brothers, to live on in the hearts of their peers and the many friends they made while attending Camas schools. Brothers Jackson, Will, and Rob Warren, ages 14, 13, and 9, were killed when the plane piloted by their father, William "Tiger" Warren, founder of Macheezmo Mouse restaurants, crashed into the Columbia River in 1999. The center features activity areas reflecting the interest of each boy. Rob loved to perform, so Rob's Playhouse offers kids a stage and sound studios. Will was artistic, and art classes and programs are offered in Will's Studio. The Jackson Room offers a cozy, library-like area with computers reflecting Jackson's enjoyment of technology. Jackson was the ninth-grade Skyridge Middle School student body president at the time of his death. The school vice president refused to fill his chair during their student council meetings, and the group placed Jackson's name on their gavel. The gavel is still in use. "Together with all of Jack, Will and Rob's friends, we built our way out of the wreckage of despair," Bidwell says. "What stands there now is good, a lasting place for the families of Camas. It was an honor to be part of such a community." (Courtesy of the *Post-Record*.)

Charles Robert Tidland

Industrialist Bob Tidland (1923–2013) created a successful, international manufacturing business headquartered in Camas making machinery for paper mills. Based on his father, Ed Tidland's (1889–1956), invention—an air-expanding core shaft—the two went into business to build it, establishing Tidland Machine Company in 1951. The enterprise grew to seven manufacturing plants around the world. The brand became a standard, with sales agents in more than 30 countries. When the corporation was sold in 1995, it still employed over 200 in the Camas plant alone. Tidland was a member of the Camas City Council for nine years and a trustee of the First Baptist Church and, later, the Camas Church of the Nazarene. A humble, kind, and persistent man, he was a generous contributor to the community. (Courtesy of Roberta Tidland.)

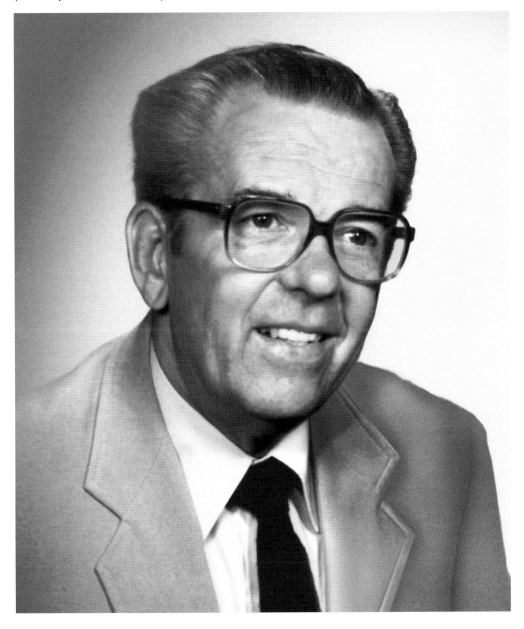

Seth Davidson

A true local legend, Seth Davidson (1898–1971) was known for his large personality and daring feats. His taste for risk may have begun during World War I as a motorcycle dispatch rider, where he received shrapnel wounds in the line of duty. He went on to pilot planes in the Army Air Corps Reserve at Pearson Air Field, make parachute jumps, perform with Tex Rankin's aerial circus, and perform bold motorcycle stunts. Riding atop a speeding freight train for movie cameras, Davidson landed in the hospital when the engineer unexpectedly braked. In 1927, he was the first to ride a motorcycle to the 10,000-foot level of Mount Hood, and in 1930, he ascended more than 1,200 feet to the top of Beacon Rock along the perilously narrow and winding footpath, which included bridges and stairs. Davidson came to Washougal in 1936. He had worked as a Multnomah County sheriff's deputy and served as a Clark County commissioner from 1949 to 1953. In a sad twist of fate, his adventure-filled life ended in a single-car accident while traveling westbound along Highway 14 near Lady Island. (Courtesy of Multnomah County Archives.)

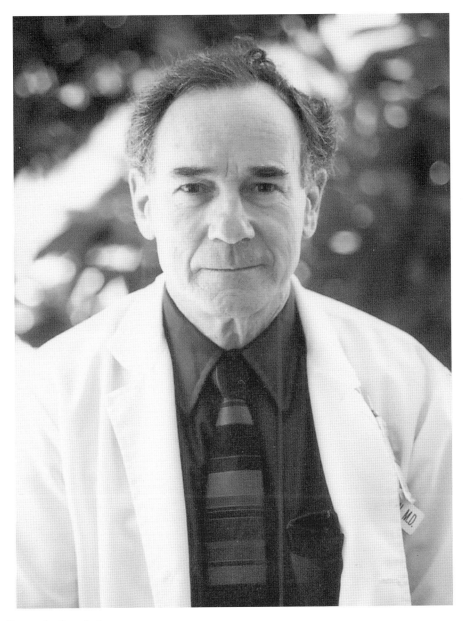

Dr. Peter A. Goodwin

Peter Goodwin (1929–2012) was a caring, well-respected, and longtime Camas physician. However, his most gratifying professional achievement was his work to craft and champion Oregon's Measure 16, the "Death with Dignity Act." This landmark legislation allowed terminally ill Oregonians to end their lives through the voluntary self-administration of lethal medications, expressly prescribed by a physician for that purpose. In the early 1970s, Goodwin was approached by a long-suffering cancer patient to help end that patient's life. Motivated by this experience and those of other terminally ill patients, Goodwin became increasingly involved in end-of-life and physician-assisted suicide issues, as well as in improving care for the terminally ill. Diagnosed with a rare and progressive neurodegenterive disease, Goodwin took his own life in accordance with the law he helped put into place. He was surrounded by family in his Portland home. (Courtesy of Nikki Nadig.)

Jimmie Rodgers

With more than 40 top 10 hits in the late 1950s and 1960s, Camas native Jimmie Rodgers is one of the early superstars of that era. His biggest No. 1 hits include "Honeycomb," "Kisses Sweeter Than Wine," "It's Over," and "The Long Hot Summer," which was nominated for an Oscar. Several commercial jingles were taken from his songs. "Honeycomb" was used for Honeycomb cereal; and the "Oh, Oh, Spaghetti-O's" jingle came from the song "Oh, Oh I'm Falling in Love Again." Rodgers was in two motion pictures, *The Little Shepherd of Kingdom Come* and *Back Door To Hell*. He also had his own national variety television show. An unprovoked attack in December 1967 by an off-duty Los Angeles police officer left Rodgers almost dead and with severe head injuries. Many, many surgeries, therapy, and faith in God brought him back to the stage. Rodgers not only still performs, but in his spare time, he is an author. His autobiography is *Dancing on the Moon*. He also produced children's animation projects and has a novel, *The Seven Horsemen*, coming out soon. He loves to speak of the uplifting story of his recovery at public events. Rodgers is happily married and has five adult children. He lives in the Palm Springs area with his wife, Mary, and their Boston terriers. (Courtesy of Jimmie Rodgers.)

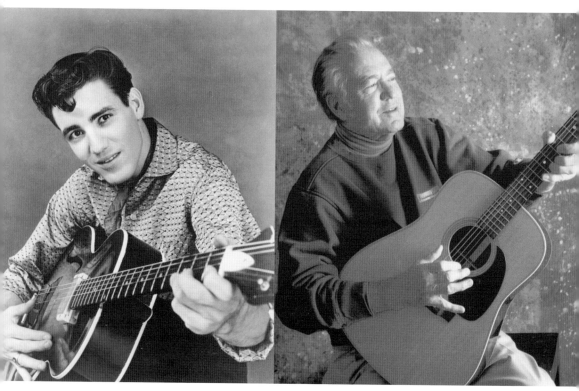

Greg Biffle

Getting his start in racing on the back roads of Camas, Greg Biffle (b. 1969) drives the No. 16 Ford Fusion for Roush Fenway Racing in the NASCAR Sprint Cup Series. He gained national attention when he won the Camping World Truck Series Championship in 2000. Biffle then went on to win the NASCAR Nationwide Series Championship in 2002. He has accumulated multiple wins in the Sprint Cup Series, including six wins during the 2005 season alone, and he has finished as high as second in the season point standings. He is the only current driver with the potential to win a championship in all three of NASCAR's national touring series. Away from the track, Biffle is known as an avid outdoorsman and animal advocate. Biffle and his wife, Nicole, founded the Greg Biffle Foundation for the well-being of animals in 2005. (Courtesy of Greg Biffle.)

Ward Grove

Thanks to aviation pioneer Ward Grove (1910–1993), recreational pilots in the Camas-Washougal area have a place to call home at Grove Field. Grove received his private flying license at age 18 from the Tex Rankin Flight School in Portland, Oregon. Later, during World War II, he worked as a flight instructor at Tex Rankin's Air Academy in Tulare, California. After the war, he and his wife, Kessie, cashed in their war bonds and bought land in Fern Prairie to start their own airport. Grove instructed many returning veterans to fly through the GI Bill. In 1961, the Port of Camas-Washougal bought the runway, but he and Kessie stayed in the small house on the property and worked as caretakers. He also repaired planes and operated the airport gas pumps. Grove continued flight instruction until 1975. (Courtesy of Port of Camas-Washougal.)

Wayne Havrelly

A product of Ed Pontes's revolutionary Television Tech program at Washougal High School in the 1980s, Wayne Havrelly (b. 1964) went on to a successful television news career. With Pontes as a mentor and supportive parents at home, Havrelly began gaining experience while still a student at Eastern Washington University. In his senior year, he landed a full-time reporter/anchor job with KHQ in Spokane. From there, he went to Orlando, then Seattle, and, in 2007, he joined KGW News Channel 8 in Portland. Wayne's standard of excellence has been recognized with several Emmy wins and more than 20 nominations as well as two national awards for investigative reporting. Havrelly still credits Pontes and his Television Tech program for launching his career in this exciting industry. (Courtesy of Wayne Havrelly.)

Carl Buhman

Although he was a talented carpenter and a well-established chicken farmer who sold eggs in the Washington State Egg Coop for 30 years, Carl Buhman (1884–1966) was legendary for distilling delicious corn whiskey during Prohibition, or "the long dry spell." As a chicken farmer, German-born Buhman would purchase the needed corn mill for his spirits without suspicion. When Buhman had a batch for sale, there would be a parade of cars up and down his long driveway. The garage door, set a certain way, was his "Open" sign. It was understood that Prohibition made criminals out of many good people. Buhman spent time in the Clark County jail for moonshine activity and received work release to build the sheriff's house. Just six months after returning home, he was arrested again and was sent to Fort Lewis, where he spent his time fixing things at the prison. (Courtesy of Rene' Carroll.)

Edward and Alice Webberley

During regular working hours, Ed Webberley (1905–1993) was a supervisor at the Camas mill and worked a 44-year career there. During the other hours of the day, he and his wife, Alice (1908–1992), were farmers on more than 200 acres of land. In the beginning, the farm mostly revolved around raising and selling hay. In the late 1940s, livestock came to the place, but in 1958, Webberley went back to hay production. At its peak, the farm brought in 5,000 bales a season. A four-man crew would put up 100 bales in an hour and 1,000 bales a day, all by hand. For many decades, young men around Camas would seek summer employment bucking hay at the farm. Webberley, a part of the large Webberley clan in the area, had a reputation for being a taskmaster. Those boys worked hard for their pay, but many fondly remember this time, this work, and this man. (Courtesy of the Webberley family.)

Anne Elizabeth Currie
There is an old missionary saying that "you can put both elbows on the table if you have traveled completely around the world and have nieces and nephews." A native of Camas and a missionary in India for 27 years, Elizabeth Currie (1905–1996) earned that right. A world traveler, her most memorable experience was in 1935, meeting the great Indian leader Mahatma Ghandi. Her travel ended in 1958, when she returned home to care for her ailing mother, Alice (1881–1968). Currie worked 10 years at the Camas Library before retiring in 1970.

INDEX

AN IMPRINT OF ARCADIA PUBLISHING

Find more books like this at
www.legendarylocals.com

Discover more local and regional history books at
www.arcadiapublishing.com